IMAGES
of America

ATHENS

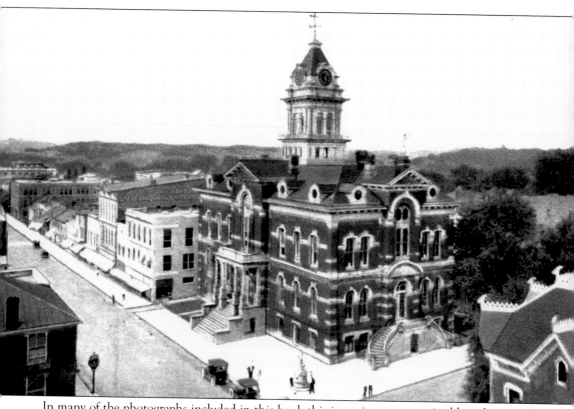

In many of the photographs included in this book this imposing structure is able to be seen. It is, of course, the courthouse. The Athens County Courthouse, a fixture on the corner of Court and Washington Streets, was dedicated on September 10, 1880, remodeled in 1935, and in 2004 the Lady Justice statue on top was completely restored. It is the third courthouse on this site, the first built in 1808 and the second in 1817.

On the cover: To anyone who has lived in Athens for any period of time, this scene pictures the heart of the city. It is Court Street, where for decades everyone went to shop, to eat, to go to a movie, and just, on occasion, to walk around. Over the years it has hosted large St. Patrick's Day and Halloween parties, countless parades, student protests, too many fires, and many changes in the businesses that give it its unique character. In many ways the street defines Athens. Through it all the bricks remain. Bricks that were made in Athens and bear this name and bricks that generate a sound as cars drive over them that can not be forgotten, no matter how long ago one last heard it. (Courtesy of the Athens County Historical Society and Museum.)

IMAGES
of America

ATHENS

Richard A. Straw with assistance from the
Athens County Historical Society and Museum

ARCADIA
PUBLISHING

Copyright © 2007 by Richard A. Straw
ISBN 978-0-7385-5066-4

Published by Arcadia Publishing
Charleston, South Carolina

Printed in the United States of America

Library of Congress Catalog Card Number: 2007926834

For all general information contact Arcadia Publishing at:
Telephone 843-853-2070
Fax 843-853-0044
E-mail sales@arcadiapublishing.com
For customer service and orders:
Toll-Free 1-888-313-2665

Visit us on the Internet at www.arcadiapublishing.com

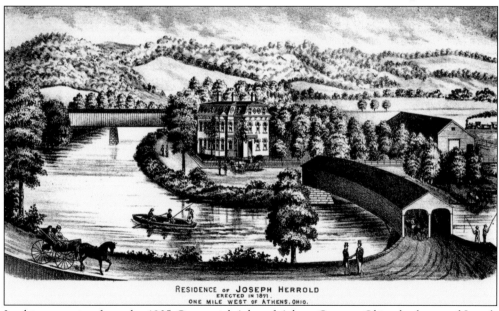

RESIDENCE of **JOSEPH HERROLD**
ERECTED IN 1871.
ONE MILE WEST OF ATHENS, OHIO.

In this engraving from the 1905 *Centennial Atlas of Athens County, Ohio*, the home of Joseph Herrold is shown in an idyllic and almost pristine setting. Built in 1871 and located one mile west of Athens along the Hocking River, this beautiful house was situated very near the site of the present day White's Mill, itself a landmark on the edge of Athens. Herrold was one of a handful of influential entrepreneurs who set the course Athens would follow in the 19th century.

CONTENTS

ACKNOWLEDGMENTS

All photographs used in this book (except one) are from the Athens County Historical Society and Museum's vast photographic collection and are used with their permission. Without the cooperation of the staff and approval of the board of directors, this project would not have been possible. I wish to thank them all for supporting my idea for this book and for providing such a pleasant and comfortable atmosphere in which to work. I want to thank director Kelee Riesbeck especially for her enthusiasm and support. I also want to thank curator Joanne Prisley and administrative assistant Diane Reeves for their assistance. Joanne has an encyclopedic knowledge of Athens and was exceptionally generous in answering all my questions. I am also grateful for their permission to use portions of their wonderful pamphlet, *Walking Tour of Uptown Athens*, in this book. I would also like to recognize the assistance and support of several other people. My old friend Steve Trout opened his house to me when I came to Athens to work on this book as he has been doing whenever I have visited him and his family for over 30 years. James Anastas has been collecting photographs of Athens for many years and scores of them appear in this book. I want to extend my heartfelt thanks and appreciation to him for having the vision to see these photographs as part of our heritage and for sharing them with our community. I also want to extend my appreciation to my editor at Arcadia Publishing, Melissa Basilone. Her support, patience, encouragement, and guidance improved this work. Thanks also go to my brother, Dave Straw, for one photograph and the use of his scanner and to members of the Athens High School class of 1967 who helped identify some individuals in two photographs. Thanks also to Karen Gilkey for her help. I am also grateful to Marjorie Stone and Robert Daniel, whose own books on the history of Athens I read with admiration. Daniel's *Athens, Ohio: The Village Years* contains a wealth of valuable information and is a model of local history. As always, Jeanie and my children, Annelise, Eli, and Brenna, have shared my enthusiasm for this project and understood my absences. Finally I want to thank my parents, Ralph and Hazel Straw, for moving to Athens in 1942 and for communicating their love of this community to me.

INTRODUCTION

By what do we understand the nature of a community, its people, its houses, businesses, geography or culture? Each of these is vital in some way but a community is more than a collection of these things. A community is a group of people who share ideas, values, interests, and to one degree or another, a way of life. By this definition Athens is indeed a community and a remarkable and appealing one at that. Athens is a community that has served as a business, cultural, and educational meeting place in southeastern Ohio for over 200 years, and the importance of Athens as a gathering place of people and ideas is profound.

The pioneer settlement that became Athens was established along the banks of the Hockhocking (Hocking) River in the foothills of the Allegheny Mountains of southeastern Ohio in the late 18th century, mainly by people originally from Massachusetts who brought with them a belief in the central importance of education to a fulfilling life. In 1797, Rufus Putnam and other members of the Ohio Company set out from Marietta to find a suitable location for a settlement that could support a university. Ohio University, the result of their efforts, was situated in Athens and chartered by the new Ohio state legislature in 1804. It became the first institution of higher learning in the old northwest territory and over the last two centuries the university and the Athens community have evolved together to become important players in the culture and history of Ohio.

While it may seem significant that Athens and Ohio University were born almost at the same time, it is easy to overestimate the size or complexity of such a frontier outpost. The first house in Athens was probably built around 1798, and it was uptown, in an area familiar to everyone. About 1800, a public ferry across the Hocking was established at the site where the South Bridge used to cross the river and a postal route was established in 1802. The first school in Athens was built in 1806 and the first courthouse building, on the site of the current one, was built in 1807. Both the Methodists and the Presbyterians had established congregations by 1810. The next year, 1811, the settlement was incorporated as a village, and by 1820, the population of the town was about 115. A newspaper, the Athens *Mirror*, commenced publication in 1825, and Athens has had at least one newspaper ever since.

Athens, like many other small towns and villages that were situated away from the country's major waterways, grew slowly in the early years of the 19th century. Despite the presence of two mills, a prosperous agricultural environment surrounding it, and the university, Athens grew very slowly. In the decade prior to the American Civil War, fewer than 900 residents lived in the village of Athens.

In this time period, as is the case today, an important key to the economic growth and vitality of any community was transportation. Canals and railroads gave Athens easier access to distant

markets and opened economic opportunities. As a result the village experienced accelerated population and business growth in the last half of the 19th century. Between 1850 and 1870, for example, the village's population nearly doubled. In the early 1840s, the Hocking Canal reached Athens, and in 1856, the first rail service reached the town as the Marietta and Cincinnati Railroad expanded its service. By 1870, one could catch the Hocking Valley Railroad at the Cemetery (Shafer) Street depot and make the trip to Columbus and back in the same day.

In the period between 1870 and 1930, when most of the photographs used in this book were taken, Athens experienced a degree of economic and urban expansion that to some degree mirrored developments in the nation. In 1875, the Athens Lunatic Asylum opened its doors and rapidly established itself as an economic force in the community, providing a market for goods and employing the largest number of townspeople. Electric street lighting was introduced in 1889, and bricks from the Athens Brick company were first used to pave some streets in town around 1892. By 1915, the town had a public water and sewer system, excellent public schools, a telephone company, three railroads serving the community, a diverse selection of churches, and a paid fire department. In 1912, after the population reached 5,000, Athens was officially declared a city. In the 1920s, population growth resulted in the expansion of the city's boundaries and the development of new areas for housing.

In spite of its reputation in the late 20th century as a college town, Athens developed in the late 19th and early 20th century as a city of workers. Foundries, mills, meat packing, warehousing, brick works, and various manufacturers could be found in the community. While College Street and streets in the east side of town were characterized by stately Victorian homes, the west side of town was an area populated largely by artisans, craftsmen, laborers, coal miners, and railroad workers. For example, both the 1898 and the 1913 Athens directories list a wide variety of businesses and occupations. A sampling would include bakers, blacksmiths, brick and clay workers, cigar makers, grocers, harness makers, and butchers. In 1898, Athens had 14 groceries, three hotels, an opera house, eight physicians, eight restaurants, and 10 saloons. By 1913, there were 33 groceries, seven ice-cream parlors, nine meat markets, 13 restaurants, but no saloons are listed. Though segregation did not exist in the town, Athens's relatively small African American population could be found living and running some businesses in the vicinity of Dean (West Washington) Street and Africa Alley (Depot Street).

The photographs in this volume reveal a city that has both retained a great deal of its charm and architectural integrity but also a city that has neglected its built heritage to a significant degree. The city's response to the fires that ravaged much of Court Street in the 1970s and 1980s has not always respected the architectural inheritance that could be a visible and active part of uptown life. The many photographs of Court Street in this book, many over 100 years old, reveal buildings that are recognizable, so to some extent there has been this remarkable continuity in this part of the city's appearance. On the other hand, the demands of a changing economy have also dictated new and innovative uses for many older buildings in town that have altered them beyond recognition as the vital historical resources they could be. This is especially true of the city's core residential neighborhoods.

A great many of the photographs in this book are of the part of Athens called "uptown." It is the source of a great deal of the appeal Athens has for its citizens and visitors alike. It has charm. While there have been shopping centers and commercial developments built on the edges of the city, the uptown has remained a vigorous and exciting place to be, both for business and pleasure. The Athens area was once a vibrant coal mining region and the remnants of that era are still to be found in some of the small communities that lie within a very short drive of Athens. Today the hills surrounding Athens are dotted with small farms, as they have always been; however, today many are attempting to carve an agricultural niche by working on sustainable, organic farms that produce food for many fine local, independently owned restaurants. In the end it must be said that Athens is an exciting mix of the old and new where the people have a fondness for the whole community. That makes it a very special place to live and work.

One

UPTOWN

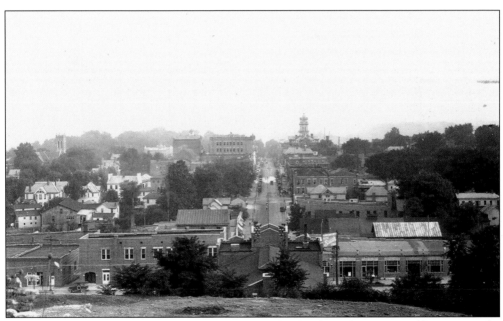

Photographs of Court Street figure prominently in this book, as the street itself represents the essence of what Athens is in the present and what it has been in the past. This photograph from the early 20th century was taken from what was known as Shale Hill, which was used as a source of clay for the Athens Brick company. Court Street runs from north to south and intersects State Street, Washington Street, and Union Street. Of note in the image are the steeple of the Methodist church on the far left of the photograph, the opera house addition in front of the city hall tower, and the courthouse tower.

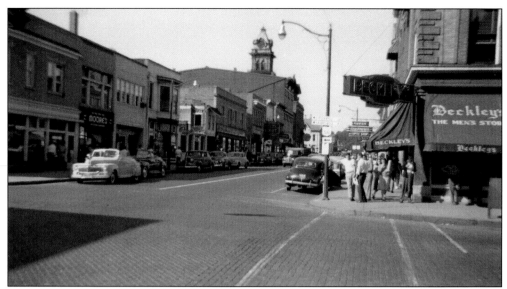

Most would agree that the heart of uptown Athens is the corner of Union and Court Streets, pictured here in 1949. Even today Court Street maintains many unique architectural features and historic buildings. For many residents and visitors alike, the outstanding feature of the street is the paving bricks that were manufactured by the Athens Brick Company and laid originally in the early 1890s.

In the mid- to late 19th century, College Street, pictured here in 1910, was a showplace for the family homes of prosperous businessmen and professionals. Among those who lived on this lovely tree-lined street were the owners of the Athens National Bank, the Athens Lumber Company, and the Athens Brick Company. A few homes on North College Street retain their 19th-century elegance but most homes closer to the university have been either dramatically altered or replaced over the years.

These two photographs show one of the most distinctive landmarks in Athens and on the Ohio University campus. The Soldiers and Sailors Monument was erected and dedicated in 1893 near the corner of Court and Union Streets on the Ohio University College Green. When the monument was built it was actually on town land, since the university did not acquire this addition to the campus until 1896. The granite base of the monument is 50 feet tall. The eight-foot bronze statue of the union soldier on the top was sculpted by artist David Richards and cast by Maurice Power at his National Fine Art Foundry in New York City. The total cost was $18,000, much of which was raised through the efforts of Gen. Charles Grosvenor. Part of the inscription on the base reads, "Athens County contributed twenty-six hundred and ten men as soldiers and sailors in the War for the Union 1861–1865. . . . The people of Athens County erect this monument in memory of those who volunteered as soldiers and sailors in defense of the Union and to perpetuate free government."

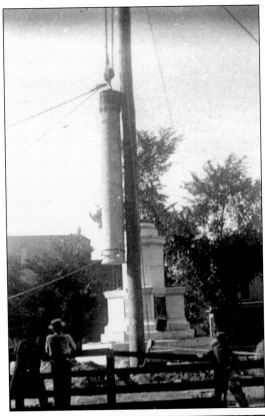

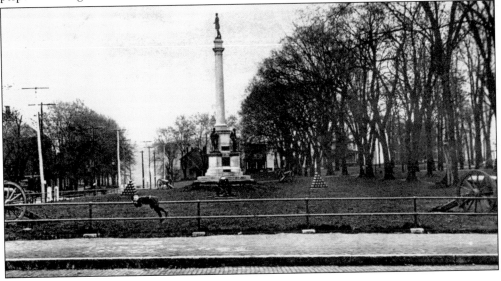

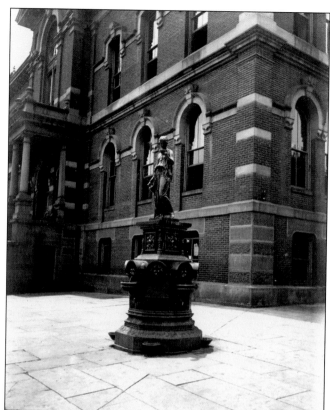

This impressive public drinking fountain occupied space in front of the courthouse until the 1950s and was placed there by the Young Women's Christian Temperance Union of Athens on May 30, 1895. The statue is a copy of a Greek statue of Hebe, the goddess of youth, who was a cup bearer in Olympus and who had youthful restorative powers.

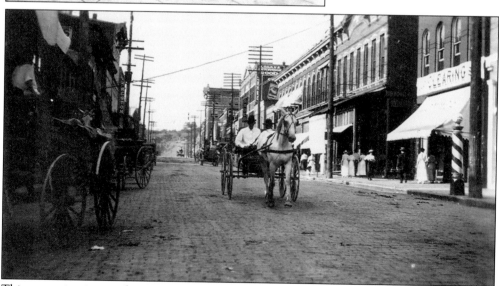

This evocative image shows a portion of the section of Court Street between Union and Washington Streets and illustrates some of the features and characteristics of a growing town in the late 19th and early 20th centuries. Well-dressed men and women stroll along the sidewalks, but the street itself is littered with some trash and horse manure, both of which presented problems for all municipalities in this era. The photograph is post 1892 since by this date some streets were lighted by electricity and brick paving had begun in Athens.

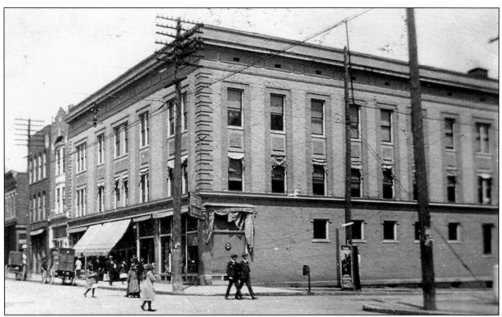

One of the more interesting aspects of crossing Court Street is the fact that on the corner of Court and Union, pictured here, crossing diagonally is permitted to this day. As the top photograph illustrates crossing diagonally has been going on for quite some time as the children in the photograph seem to be going in all directions at once. Figuring prominently in both photographs is the Lawrence Building on the northeast corner. It was built in 1909 and has served many businesses and professional offices over the years. One of the most well-known businesses on Court Street for many years was Beckley's Clothing Store for men, which occupied the major portion of the first floor of this structure. The College Bookstore is the current resident. Adjacent to the Lawrence Building and also built in 1909 is the narrow Newsom Building, with its distinctive bay windows visible in the top photograph. The building was designed for Newsome's undertaking business and furniture store.

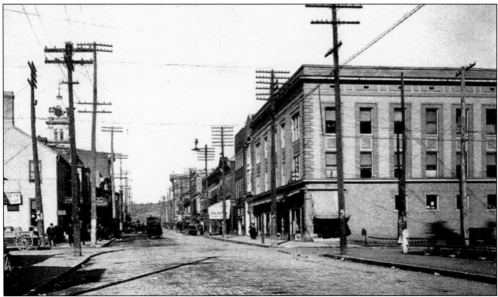

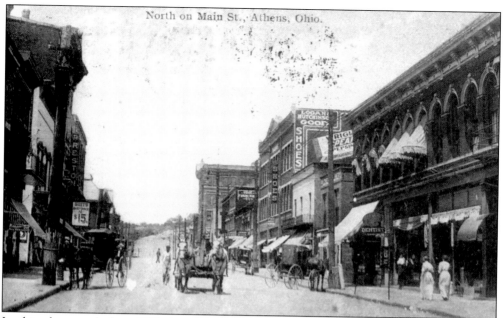

In this photograph from 1915 the section of Court Street between Union and Washington Streets is pictured. Much of the architectural silhouette of the street is largely unchanged today. On the left is the sign for Preston's Department Store and another advertising suits for $15. Grones and Link, tailors, advertised suits made to order for that amount, $5 down and the balance due upon delivery of the suit.

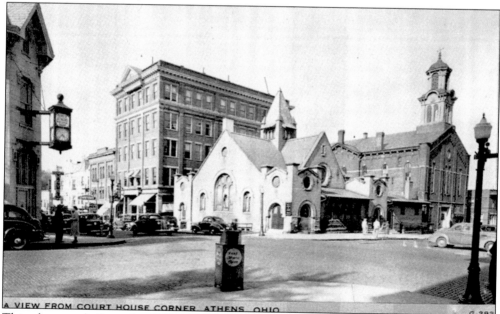

A VIEW FROM COURT HOUSE CORNER, ATHENS, OHIO.

This photograph from the 1930s illustrates three important Athens buildings that can be seen from the corner of Washington and Court Streets. In the center of the photograph is the Presbyterian church, constructed in 1903. There has been a Presbyterian church on this corner since 1828. The Athens National Bank building, which was built in 1905, is seen to the left of the church. On the right is the Athens City Building.

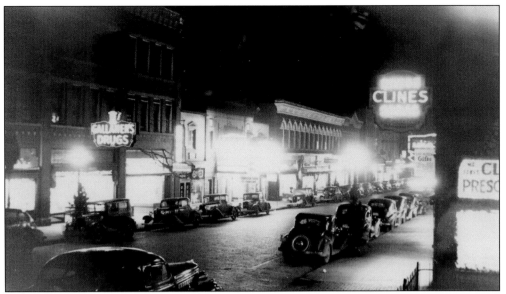

Athens after dark has always provided residents and students alike with plenty of places to go for entertainment. Court Street, when it was the absolute center of life in Athens, by necessity, also supplied most other needs for the city's population. In this photograph an unusual view of Court Street at night shows Cline's Drug Store, which was beside the courthouse, and Gallaher's Drugs on the east side.

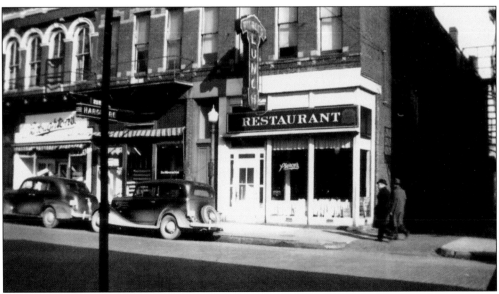

In the 1930s, when this photograph was taken, restaurants proliferated in uptown Athens. Many of them offered primarily lunches for the working men and women who took time out of their days to sit down for a hot meal at midday. Pierce's Restaurant, located at 38 South Court Street, is seen in this photograph beside Kerr Hardware.

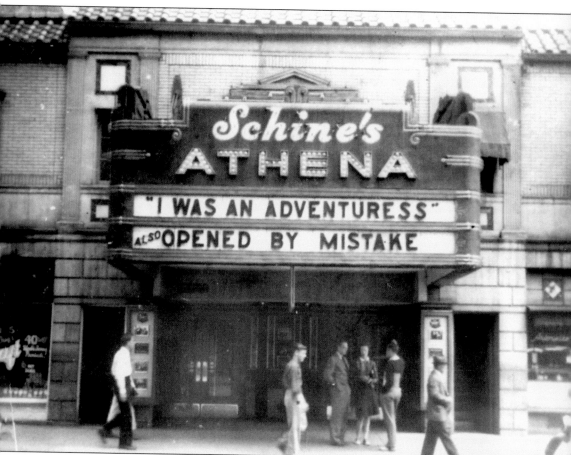

The feature presentation playing at Schine's Athena Theater on Court Street in 1940 is *I Was an Adventuress*, a light crime drama starring Erich von Stroheim and Peter Lorre. *Opened by Mistake* was a short subject made in 1934. This building was built in 1915 for the Majestic Theater, the original Court Street cinema. The yellow bricks and the red tile roofing used in its construction were made in southeastern Ohio and were unique on Court Street. The Shines chain owned a number of theaters in the Midwest during this era. To the right of the theater in this photograph is Antorietto's Confectionery, a candy store that also sold popcorn to the Athena's patrons. Ohio University purchased the theater in 2001 and restored it to the look it had in the 1940s and 1950s before it reopened in 2002. It shows first run movies again in three theaters as well as foreign and independent films. It is also home to the Athens International Film and Video Festival.

The Athens City Building, on East Washington Street, was constructed in 1874 and has served in many capacities over the years. The building was built as a town hall and originally housed town offices, a post office, and an opera house on the top floor, which seated 500–600 patrons. In early photographs of the building, a tall theater addition is visible on the rear of the building, but this was torn down by the 1930s.

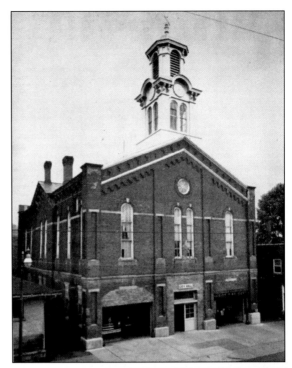

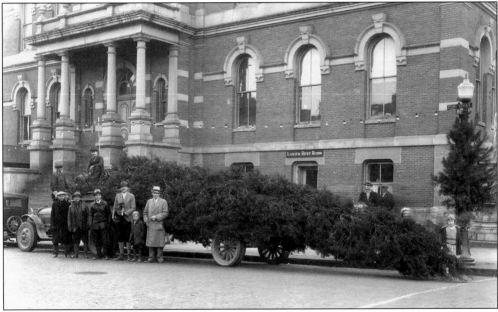

A large, decorated Christmas tree outside the Athens County Courthouse was a tradition of long standing when this photograph was taken in 1932. When the tree went up shortly after Thanksgiving, the Christmas season had officially begun. Children and adults alike gathered to watch it being pulled upright as this photograph illustrates. Pine trees and lights strung on the lamp posts were also part of the decorations. The gentleman sitting on the tree in the photograph is Charles Mapes. Other men in the photograph are identified only as Duffy, Nelson, Link, Bob Link (the boy), and Dick McKinstry.

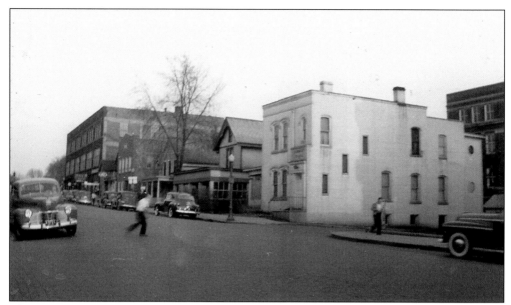

This is a scene looking east on West Union Street in Athens in early spring of 1941. Not yet in World War II, but preoccupied with news from Europe, life in small towns like Athens went on as usual. In the background is the Lostro Building, built as an automobile dealership in 1915. The three buildings in the foreground of this image have all disappeared over time.

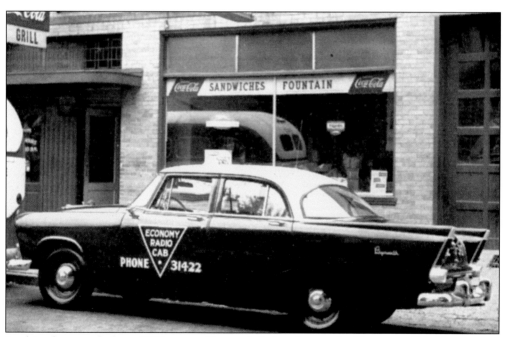

In this photograph from 1957 a new Plymouth belonging to the Economy Cab Company is shown in front of the Lake Shore Lines bus station on East State Street between Court and College Streets. At the time, Athens was served by many passenger trains each day but also by bus lines that carried students and city residents north to the Columbus and Cleveland areas as well as west to Cincinnati.

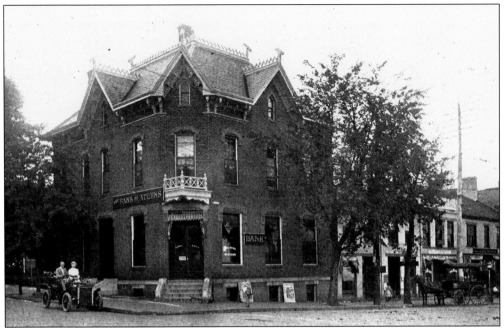

In this evocative photograph the old and the new are juxtaposed against each other. The old horse-drawn wagon sits opposite that harbinger of modernism, the automobile. In between is the new Bank of Athens building, which was built in 1883. Identified in early photographs as J. D. Brown's block, the building served the bank's needs on the first floor and provided a home for Brown's family on the second. The building was torn down in 1962.

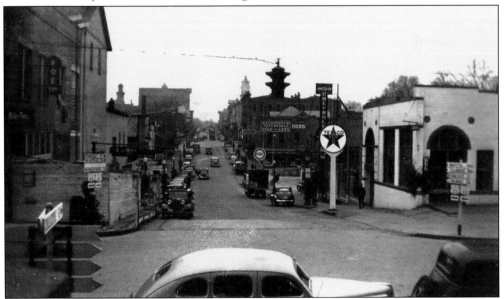

In a much later view of uptown the viewer looks south on Court Street from the intersection of Court and Carpenter Streets in the 1940s. The livery stables and blacksmith shops of an earlier era are gone but the Junod mill building can still be seen on the left in the photograph. The Jones Buick Company, which sold Buick and Cadillac automobiles as well as trucks, tires, and Texaco products, is on the corner.

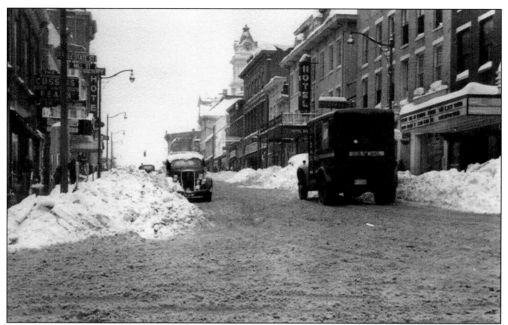

Photographers love snow scenes like this one of the aftermath of a storm in November 1950. The scene is looking south up Court Street from the corner of Court and State Streets. In the photograph the Cussins and Fearn appliance store is on the left and the Athens Hotel, originally built as the Warren House in 1872, is on the right. Remodeled in 1897, it was used as a hotel until 1970.

This mighty structure that occupies the southwest corner of State and Court Streets is the W. H. Potter Building, which was built in 1875. This particular photograph is from 1905 when the building was owned by O. B. Sloane, who was described in the *Centennial Atlas of Athens County, Ohio* as one of the town's most prosperous and successful businessmen.

Two

ATHENS BUSINESSES

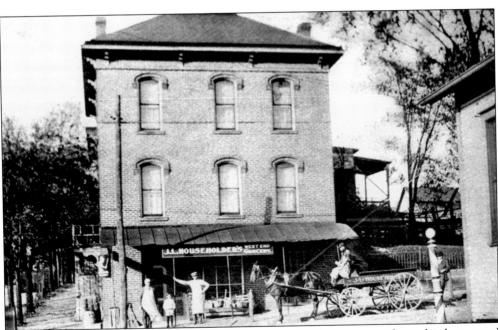

This remarkable building is well known to residents of Athens's west side, and it has served many functions over the years. Situated on the corner of Dean Avenue (West Washington Street) and Cemetery Street (Shafer Street), it was built in 1882 by Thomas Jefferson Herrold. By 1913, the building had become the place of business of J. L. Householder's West End Grocery, shown in this photograph. By 1910, the lower end of Dean Avenue was teeming with railroad workers, travelers, and the varied businesses suitable for meeting their needs.

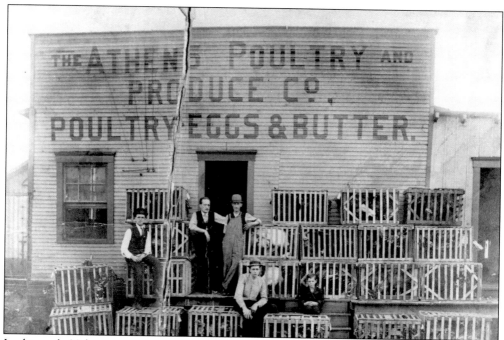

In this early-20th-century photograph the proud proprietors of the Athens Poultry and Produce Company are pictured in front of their place of business displaying some of their wares. In this era, of course, shopping was more a matter of going to several different places for specific products rather than going to one large grocery or market. The 1898 Athens directory, in fact, lists two poultry suppliers in Athens. The owners of this business were the Atkins brothers.

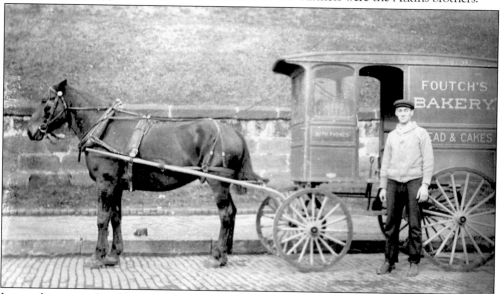

In another example of how food shopping was decentralized into many different stores, this charming photograph shows George Wise with the Foutch's Bakery wagon along West Union Street in Athens. The bakery opened in 1914 on Court Street and delivered bread to a wide market. Foutch's Bakery was eventually bought by Frank Rauch, who operated a bakery in Athens into the 1960s. The 1913 city directory lists two commercial bakeries in Athens.

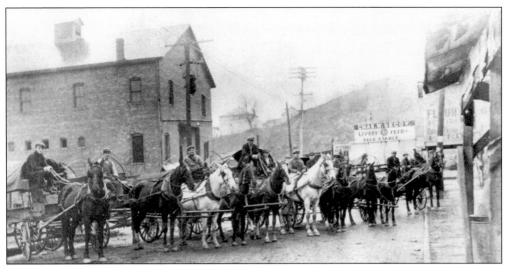

There were three livery stables on the very north end of Court Street at the end of the 19th century. The Bower Brothers livery is shown here with a number of wagons of the Central Delivery Service set for hauling. In 1904, they employed over 100 horses and could provide nearly any type of carriage or wagon. In the background is the veterinary and horse shoeing business of Charles Secoy at the foot of Shale Hill on the corner of Carpenter and Court Streets. This photograph is from 1909.

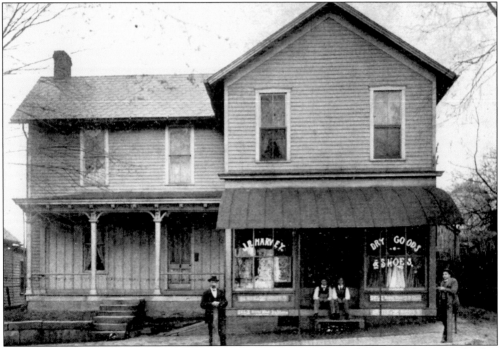

This 1904 photograph of the J. W. Harvey General Merchandise and Dry Goods store is further evidence of the commercial vitality of Athens's west side in the early years of the 20th century. Located at 216 Dean Avenue (West Washington Street), this business was across the street from a hotel and boardinghouse, just up the street from the J. L. Householder Grocery pictured earlier, and only one block from the Kanawha and Michigan Railroad train depot.

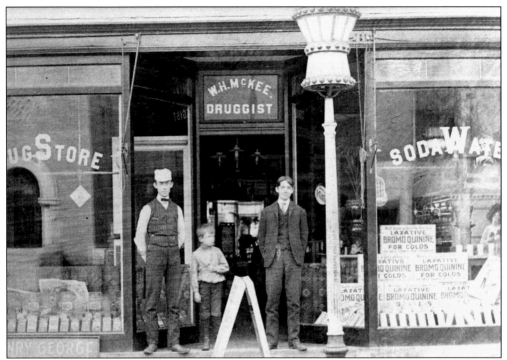

Druggists provided many services to the public in the late 19th and early 20th centuries, not the least of which was providing tonics and patent medicines. Prominent among Athens's businessmen were three druggists, Cline, Lash, and McKee. All three establishments were located on Court Street and the one pictured here in a 1900 photograph is McKee's Drugs.

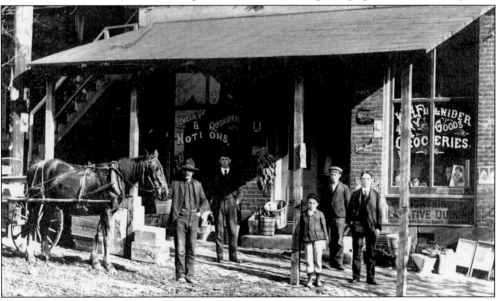

This is a beautiful, but largely unidentified photograph, reminiscent of an era long past in Athens. It is another of the many, many small grocery and dry goods stores that were scattered all over the town at the dawn of the last century. For example, the 1913 Athens directory lists 33 grocers and nine meat markets when the city had only around 6,000 residents.

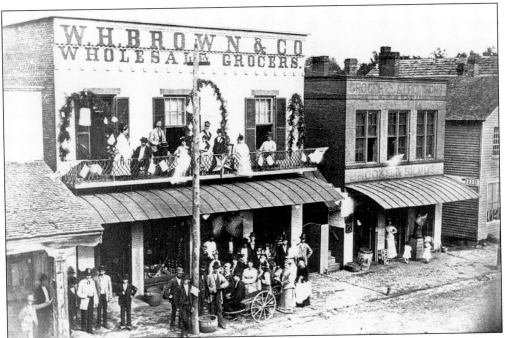

In this very early photograph of two Court Street businesses from about 1875 everyone is out in front of the W. H. Brown and Company Wholesale Grocery business. Brown was one of the first Athens merchants to branch out from selling directly to customers to providing a wholesale service to the many country stores around Athens and southeastern Ohio. The building on the right is the grocery and dry goods business of Isaac Silvus founded prior to 1870.

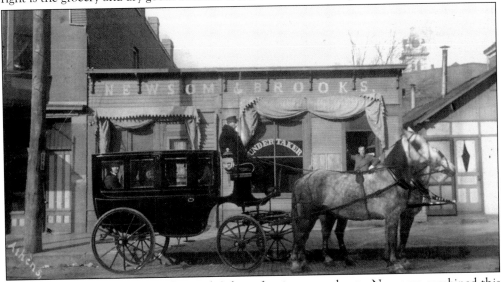

Charles S. Newsome was one of several Athens furniture merchants. Newsome combined this business with his undertaking enterprise until he sold off his furniture store and concentrated on his undertaking business. This photograph shows his business and an impressive horse-drawn carriage. The placement of the courthouse in the background suggests a location of West Union Street for this business. This photograph is from before 1909, because in that year Newsome built a new building at 42 South Court Street for his undertaking establishment.

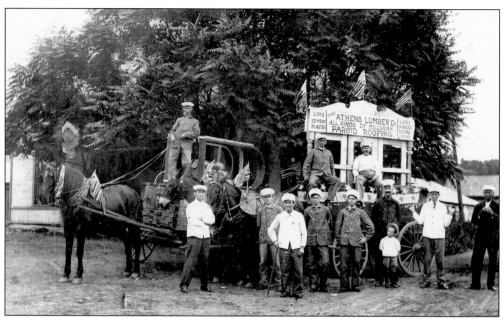

Both of these photographs show workers and equipment from the Athens Lumber Company. In the top photograph the men appear to be ready to join a patriotic parade of some kind. Both horses and one of the wagons are decked out in flags and the stars and stripes. The wagon in the background is loaded with lumber and roofing materials. The bottom photograph captures a spontaneous moment of a work day. Notice the small dog that the gentleman on the right is holding. The Athens Lumber Company was established in 1886 by five local entrepreneurs, including Henry O'Bleness. It located its mills and workshops on West Union Street close to the train depot where it remained a mainstay of the Athens business community for much of the 20th century.

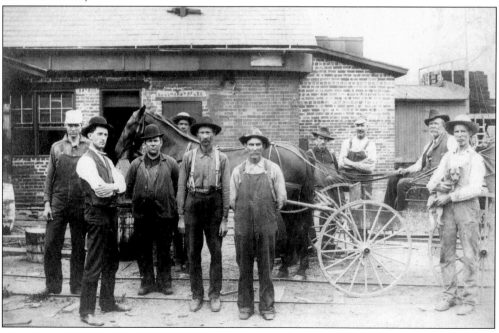

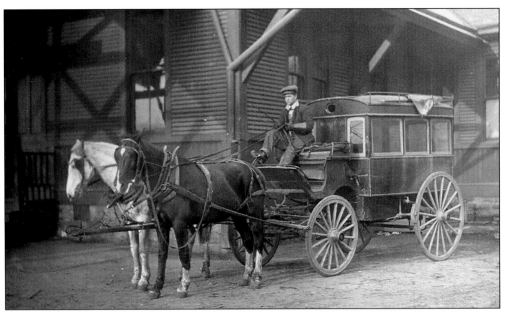

The availability of public transportation was just as important in 1900 as today. Athens was served over the years by several railroad lines and had by 1900 two depots, both in the west end of the town. This photograph shows a cab owned by the A. L. Johnson Transfer Line. They provided transfer service for passengers and trunks. Their advertisements stated, "We meet all trains day or night."

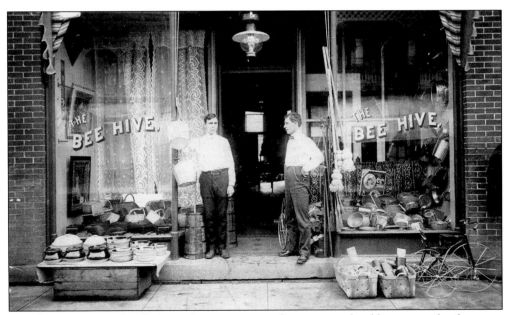

Woods Bee Hive, 30 South Court Street, was one of many specialized businesses that began to crop up in Athens at the end of the 19th century. The Bee Hive, as can be seen from the window displays, sold a variety of items.

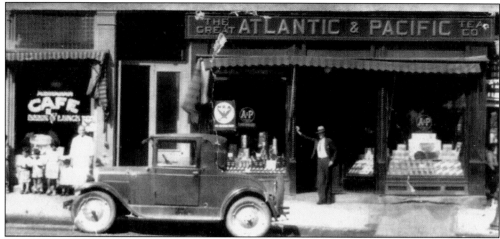

In 1873, O. B. Sloane opened his dry goods store in the Sloane Building on the corner of West State and Court Streets. In 1926, Joseph Abraham bought the building and opened a café in part of the building and leased the other part to the A&P company, a nationwide chain of grocery stores. In this photograph, which was taken in 1934, Abraham is shown with his daughter and four of his sons. Eventually Abrahams Café would move to West Union Street and the A&P would move to Stimson Avenue, but the Abraham family retained ownership of the building until 1986.

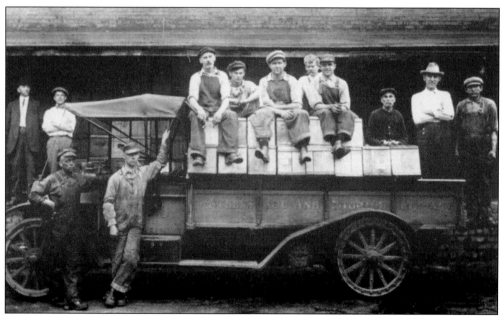

Businesses that produced ice became a welcome addition to life in small towns and villages in the early 20th century. This photograph shows the management and some of the workers at the Athens Ice and Storage Company posing around their truck sometime in the 1920s.

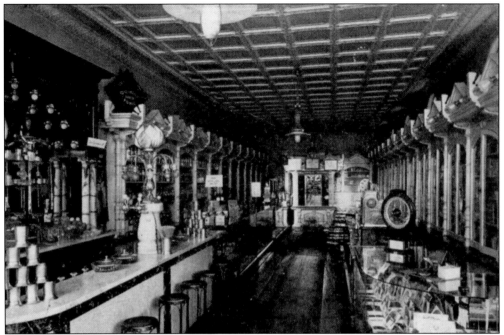

As late as the 1960s, students congregated at Cline's Pharmacy to enjoy ice-cream sodas and cherry cokes. Cline's, on Court Street, just beside the courthouse, was an institution in Athens from 1903, when J. H. Cline remodeled an older building, adding a third floor and brick front. From the beginning Cline's was known for its sodas, and in 1904, the owner built an ice-cream factory on the rear of the building to supply his business's ice-cream needs and to ship to surrounding towns.

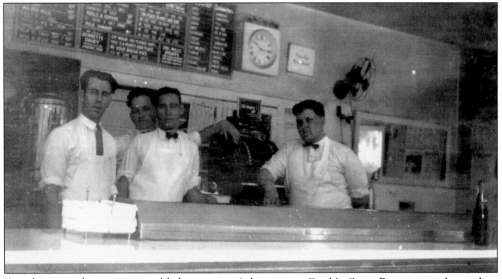

Another popular eating establishment in Athens was Cook's Spot Restaurant, located at 49 South Court Street in the building that currently serves as Perk's Coffee Shop. In this photograph of the counter crew taken in 1920, Bill Poling, who would later manage the Kroger store on Union Street, is on the far left. Milk shakes were 15¢, rolls and coffee cost a dime, and a piece of pie was also 10¢.

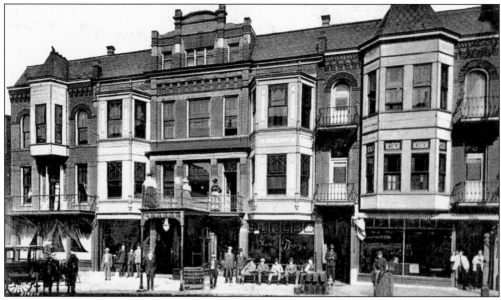

By 1900, the ornate and elegant Berry Hotel set the standard for high-class accommodations in Athens. Owned and operated from 1892 to 1921 by Edward and Martha Berry, the Berry Hotel was Athens's largest. When it was sold in 1921 it had expanded to 90 rooms and contained an excellent dining room, barber shop, meeting rooms, offices, and a ballroom. Having met at the Albany Enterprise Academy the couple married and moved to Athens in 1877. Shortly thereafter, they began a catering service and then opened a small restaurant that specialized in oysters, steaks, pie, and homemade ice cream and candies. Success allowed them to purchase the hotel in 1892, which they immediately turned into a first-class establishment with all modern appointments. Their prosperity allowed them to serve the Athens community in many ways. In 1905, they donated the land and money to build the Mount Zion Baptist Church, and in 1915, Edward gave a significant amount of money towards the new Alumni Gate at Ohio University to honor its first African American graduate, John Newton Templeton. In 1961, Ohio University bought the hotel and sadly removed the original facade. In 1973, it was torn down.

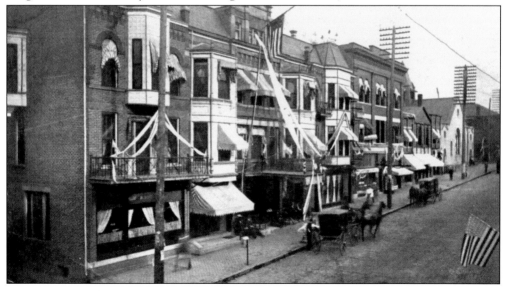

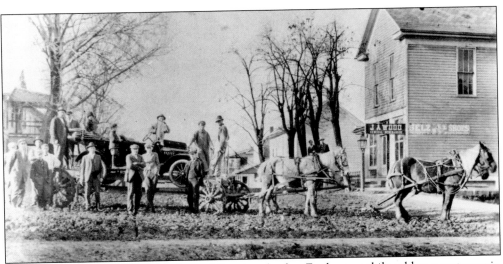

In the top photograph, Fred Beasley is delivering the first Ford automobile sold to a customer in Chesterhill. At this time Beasley's business was still located in Amesville. From the looks of it though, they needed an older form of transportation to navigate their way through a good deal of mud to reach their destination. In the early years of the 20th century, the mobility of automobiles was certainly limited by the scarcity of paved streets and roads. In 1912, a Ford automobile cost more than the average person made in a year so the delivery of such a curiosity was quite an event. At this time, G. W. Hopkins and Company sold Fords in Athens, but Fred Beasley would eventually move his automobile dealership to Athens. His Ford showrooms and body shop would be located on East Carpenter Street for many years where he supplied Athenians with America's most popular vehicles.

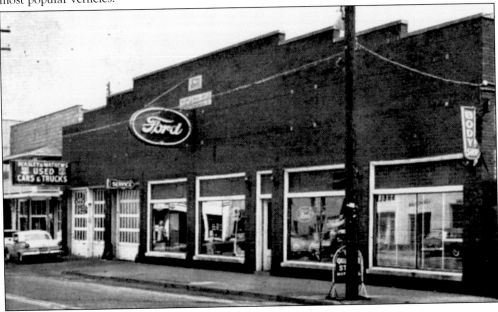

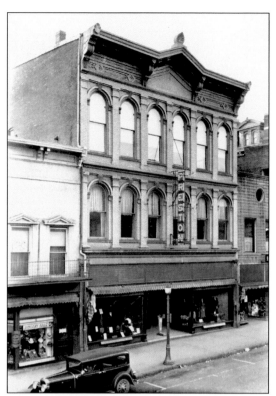

In 1910, F. L. Preston opened his department store in the Masonic building just a few doors down from the courthouse. The Preston family had much experience in the retail trade in Nelsonville and Columbus before coming to Athens.

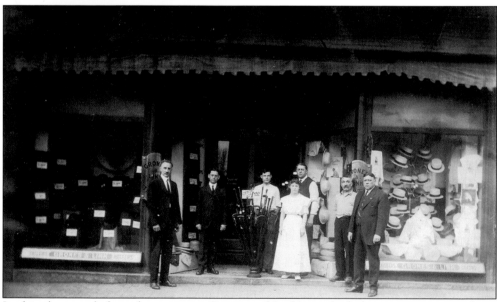

In this photograph from the same era, Grones and Link's men's clothing store is pictured just beside Preston's Department Store. Grones and Link offered a higher priced variety of men's furnishings and they also offered custom tailoring. They advertised themselves as the leading tailors and suppliers of men's clothing in Athens, with wool suits custom-tailored for $15 and wool trousers for $5. This may seem inexpensive but consider that a good meal in a restaurant would cost only 25¢.

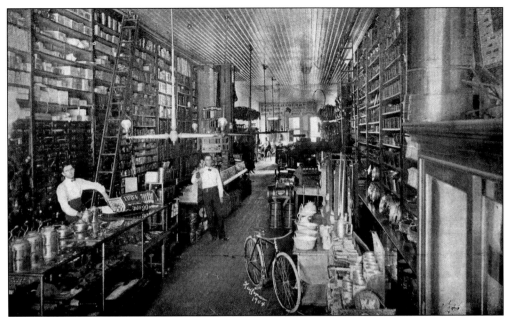

Hardware stores were among the most common types of businesses in any small town at the end of the 19th century because they sold everything from household supplies to equipment for gas heating or electrical lighting. This is illustrated well in this 1904 photograph of the interior of Goldsberry's Hardware store on South Court Street. In 1915, the store was sold and became Kerr Hardware, which remained in business in Athens in the same location until 1978.

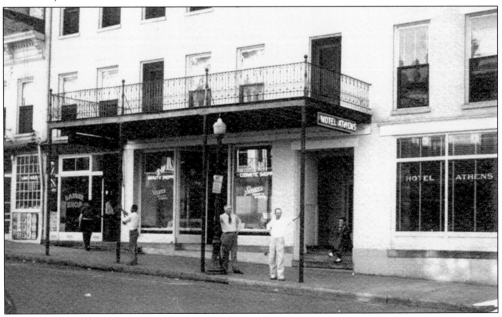

Built originally as the Warren House and located on the west side of North Court Street, the Athens Hotel served customers from the early years of the 20th century. Although never as refined as the Berry Hotel, the Athens Hotel maintained a steady business. Steppes Beauty Shoppe, another venerable Athens business, was located at this time in a first-floor shop of the hotel.

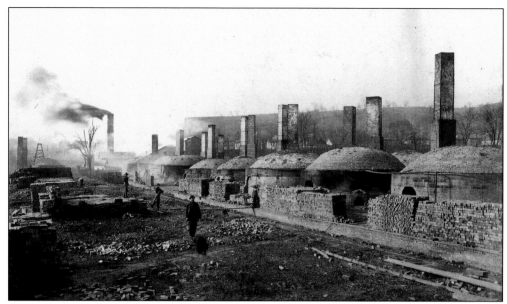

The Athens Brick Company was one of the largest industrial employers in Athens at the beginning of the 20th century. With its plant along Stimson Avenue and gaining its materials from North Hill, or Shale Hill as it was called, the brick works supplied bricks for paving Athens's streets and for building materials in Athens and well beyond. Making bricks was brutally hard labor and a 60 hour work week was common. Because much of the work was unskilled, the work force tended to be rather transient. The Athens Brick Company was eventually forced out of business in the 1920s because of competition from larger concerns and by competition from other construction and paving materials. An oft repeated story in Athens is that Athens brick was used to pave the Indianapolis Speedway although no proof of this claim has ever been established.

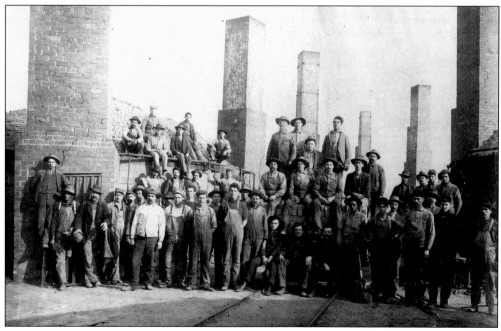

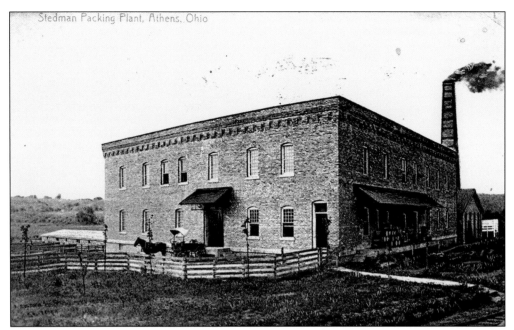

The F. C. Stedman Packing plant, near the railroad tracks off West State Street, provided a market for beef cattle and hogs to the Athens and surrounding areas. It also served as a grocery wholesaler.

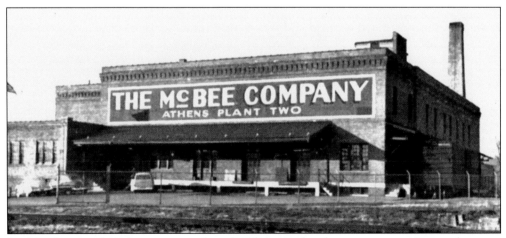

In this photograph it is easy to see how buildings evolve from one generation to the next, changing to meet the needs of a new era. This is the same building as in the photograph above, although it has been enlarged and changed considerably to meet the demands of its new resident, the Royal McBee Company. In the 1950s, 125 employees worked here.

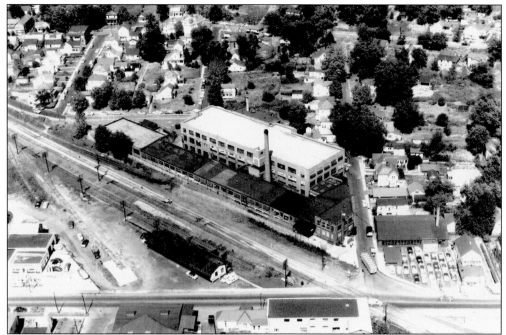

In the second decade of the 20th century, Charles F. McBee and Henry Zenner organized the McBee Binder Company in Athens in order to find a better way to organize the filing and binding of railroad freight bills. In 1916, the main office and Plant 1 were under construction at the corner of West Union and Smith Streets, and by the 1920s, the company was one of the largest employers in Athens. Eventually the company would have three major plants in Athens, all located within proximity of each other in the west side of town, and by the 1950s, total employees would number close to 1,000 in Athens. In 1956, as a subsidiary of Royal Typewriter, Royal McBee produced one of the earliest computers, the LGP-30, known as a desk computer because it was the size of an office desk. In 1955, Royal McBee ranked 344th on the Fortune 500 list of businesses in the United States.

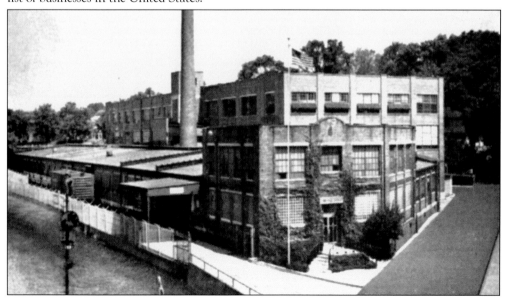

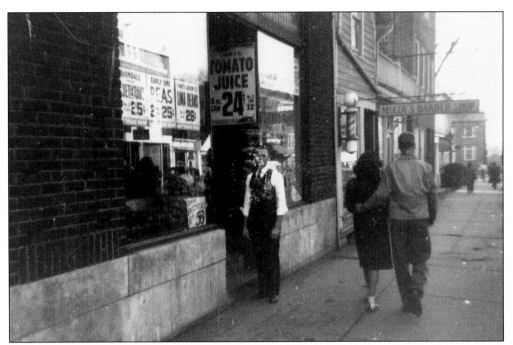

Until recently, grocery stores have always been a part of the retail environment in uptown Athens. This is the Kroger store on West Union Street just around the corner from Court Street in 1933. The young man standing in front is Bill Poling, the store manager.

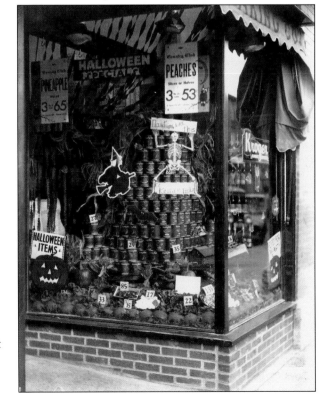

An array of fresh and canned foods adorns the window of the Kroger store in 1932 during the Halloween holiday season. The Halloween themes have not changed much over the years, but the prices have. Although difficult to read, the sign on the skeleton reads, "Don't look like this, eat Kroger foods."

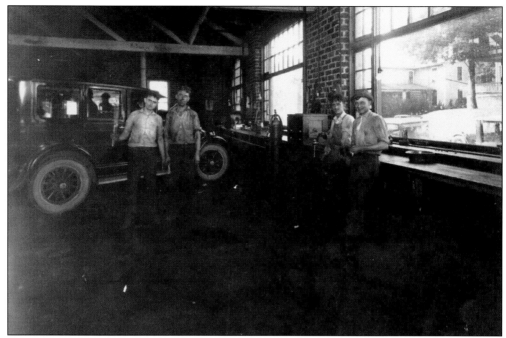

Automobiles began arriving in Athens in the early 20th century with the first dealership being established in 1909. By 1913, there were several garages in the city that specialized in the repair and maintenance of the new machines. The young working men pictured here are employees of the Herman Douglas Garage, and the photograph is from the early 1930s.

A newspaper is a vital part of any municipality's evolution, and Athens has had a weekly or daily paper for most of its history. The Athens *Mirror* was first published in 1825 and its successor, the *Athens Messenger* became a daily in 1905, nine years after its operations were taken over by Fred Bush. This is the building that housed the paper for much of its tenure, shown here in the 1930s. The building was erected in 1925.

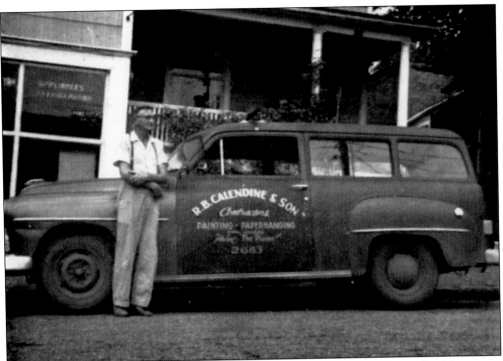

Small businesses were always a vital part of Athens's economy and remain so today. Many types of services were offered to the city and the surrounding area by enterprising individuals. This 1957 photograph from the Athens directory shows R. B. Calendine advertising his painting and wallpaper hanging business. Ironically, he is standing in front of 226 West Washington Street, the location of another small business, Straw Electric Company.

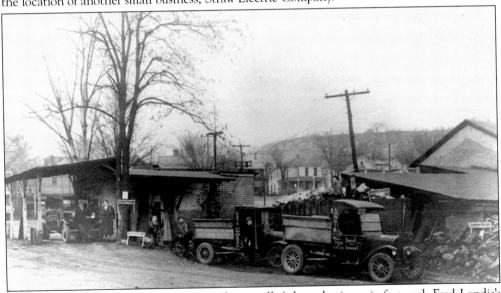

In this photograph from the 1930s, another small Athens business is featured, Fred Landis's Luhrig Coal business located on the corner of Kern Street and Stimson Avenue. Selling sand and gravel as well as coal, Landis was a promoter of local resources. On the sign it reads, "Happy days are here again, buy Luhrig coal."

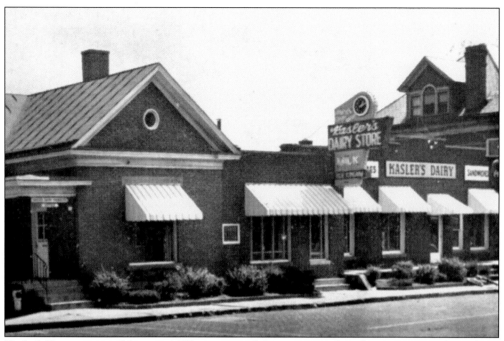

Kasler's Dairy, pictured here in 1957, was one of the most popular after-game spots for Athens teenagers into the 1960s. Carrying on the tradition of several earlier ice-cream manufacturers in Athens, Art Kasler's dairy and Fairmont Dairy were the leading providers of milk, ice cream, and other dairy products to Athens and the surrounding area.

From the 1920s through the 1960s Athens, like most other towns and cities, had many small restaurants and luncheonettes that catered primarily to the working men and women in town. Among them was the Little Ritz, shown here in its location on West Union Street close to the McBee plant at the corner of West Union and Smith Streets. It was the first office of the McBee Company.

Three

HOMES, SCHOOLS, AND CHURCHES

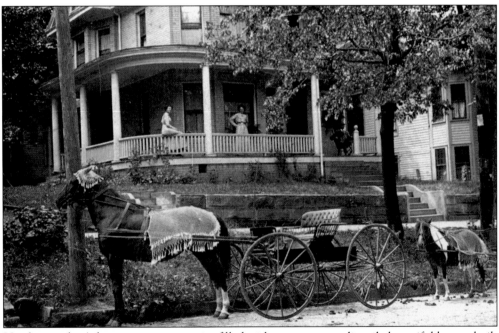

Until recently, Athens was a community filled with many extraordinarily beautiful homes built by prosperous businessmen and professors. Court, State, College, Washington, Union, and Congress Streets were populated by the uptown merchants and professionals who could easily walk to their places of business or work. The photograph here is an enticing window into a past that seems romantic to many in contrast to the noise, hustle, and bustle of modern life. The Brook house, at 59 North Court Street, was built around 1900 and is one of the few stately homes on Court Street still standing and recognizable.

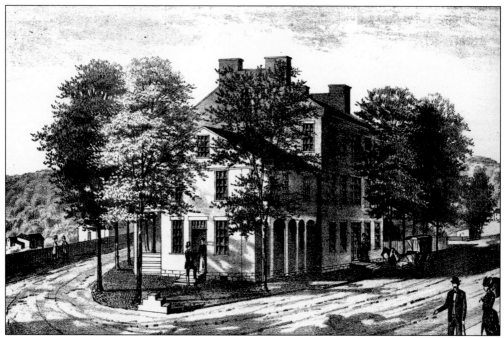

This is the home of Judge Ebenezer Currier, shown here in a print from the 1875 *Atlas of Athens County, Ohio*. It was located on the triangular block between East State Street, Mill Street, and College Street known as flatiron block. The house served many functions through its life including residence, store, tavern, and stagecoach stop.

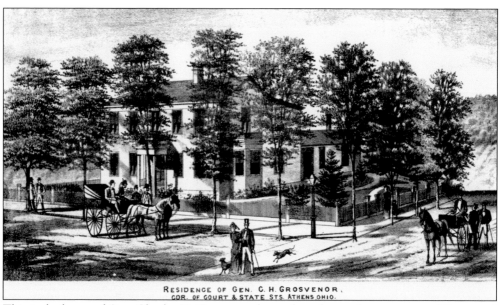

RESIDENCE OF GEN. C. H. GROSVENOR,
COR. OF COURT & STATE STS. ATHENS OHIO.

This is the home of Gen. Charles H. Grosvenor, located on the northwest corner of Court and State Streets. The print is also from the 1875 *Atlas of Athens County, Ohio*. This house was moved at least twice, first in 1902 to make way for the construction of the Campbell building, and it now rests in a much altered form behind the building that houses the Athens County Historical Society and Museum.

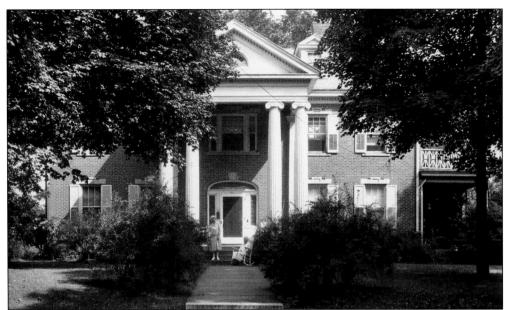

These two photographs illustrate the stately mansion built by Gen. Charles H. Grosvenor at 52 University Terrace in 1901. In the top photograph, taken in 1927, Louise Grosvenor is seen sitting in the rocking chair. She was the daughter of Judge Ebenezer Currier, whose home is pictured on the previous page. In the bottom photograph, which is from an earlier time, although no exact date is known, the house is elaborately decorated with flags, streamers, and bunting. The huge flag has 42 stars on it; a design that was only made in 1890. General Grosvenor, a Civil War veteran, had a long and distinguished career as a congressman. He served in Washington from 1887 to 1907, when he returned to Athens to enjoy retirement. According to Robert Daniel, Grosvenor's death in 1917 was mourned by the entire community. A large public funeral was held and local schools, the university, and local businesses were all closed for the occasion. The house remained in the family until the 1950s. Since then, it has been used by the Episcopal Church, and in 1980, it was purchased by Ohio University and presently houses the Konneker Alumni Center.

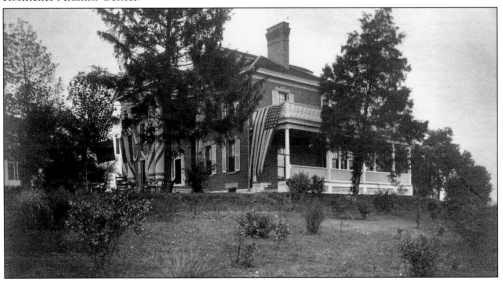

This house, which was built by Daniel Reed in the 1840s, sat on the northwest corner of Court and Union Streets until the 1920s. Reed, who held several positions with Ohio University, would later in his life become the president of the University of Missouri. Like most of the homes that once stood uptown in Athens, the Reed house was torn down and replaced by a large business block.

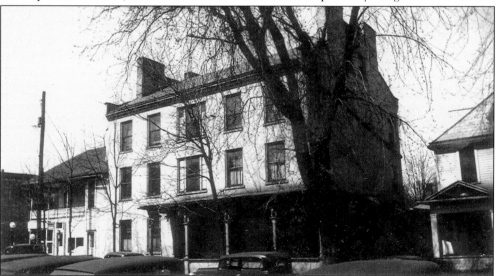

If this house looks familiar, it should because it is the same building, the Currier House, as illustrated in the top photograph on page 42. While it has been altered by the time this photograph was taken in 1925 the third floor remains intact, although the structure has been changed to accommodate a gasoline filling station. The third floor would later be removed and the building altered almost beyond recognition. It was torn down in the 1960s.

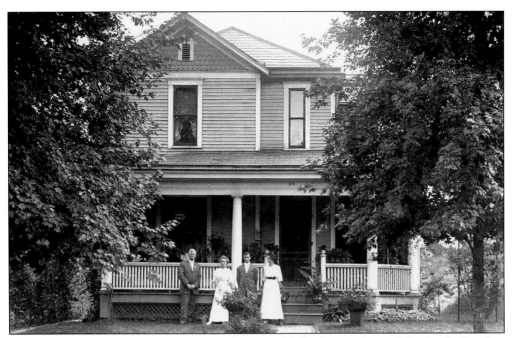

In this unidentified photograph, two couples, most likely the members of the family that live in this solid home, are standing in their front yard. It is certainly summertime as the porch is filled with the potted plants that were so popular in the years around 1900. The individuals are especially well dressed, suggesting a special occasion for the photograph.

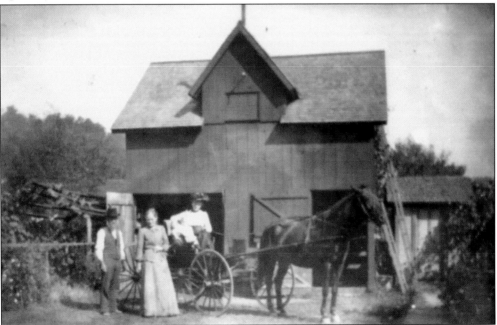

In the horse-and-buggy era, carriage houses were quite common outbuildings that were usually tucked neatly behind the family home in much the same way as a detached garage would be today. This is the carriage house that sat behind the home of Dudley and Mary Fuller at 34 Morris Avenue in Athens. Edyth Fuller Lawhead is holding her baby, Mary Lou, in the buggy.

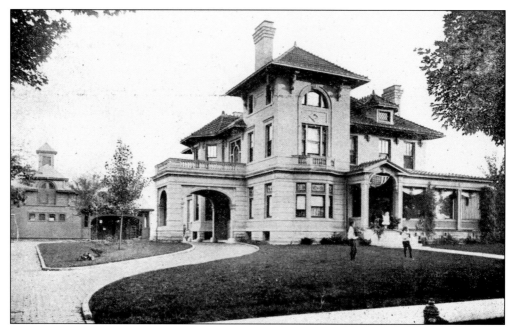

The current home of the president of Ohio University, this extraordinarily beautiful mansion on Park Place was the residence of Clinton L. Poston, a legendary coal baron. He controlled thousands of acres of coal lands in southeastern Ohio and was a founding member of the Sunday Creek Coal Company, which in 1905, when it was created, was one of the largest coal companies in the United States. In this 1899 photograph the exquisite architectural details of the home are evident, although the richness of the structure has not deterred the young men in the front yard from a game of baseball. The home was acquired by Ohio University in 1951 and has been remodeled and restored on several occasions.

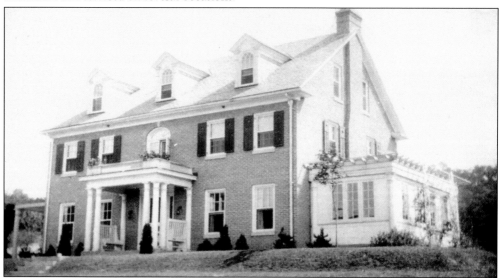

This dignified home at 42 Utah Place was built in the 1920s when Athens was growing and new housing developments were sprouting up. One of the finest was well removed from the town center, out East State Street where some of Athens's wealthiest citizens were now building their residences.

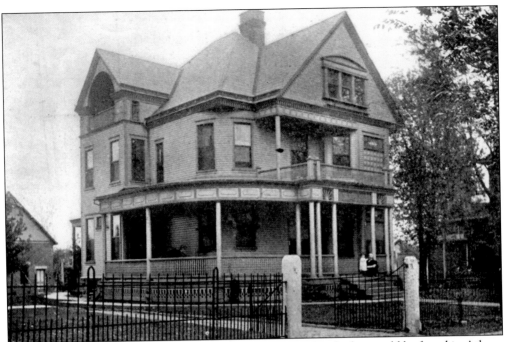

This is one of the finest examples of Victorian architectural style that could be found in Athens at the beginning of the 19th century. Homes such as these were built by local craftsmen and served middle-class professionals and their families for decades. Houses like this one were elaborately painted in quite striking shades of colors. Favorites were maroon, gold, greens, yellow, and shades of blue. This house is at 10 South College Street, though it has been significantly altered in appearance.

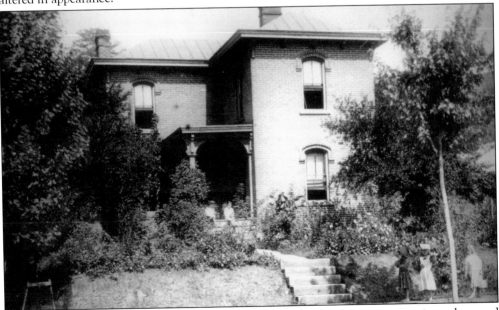

This house is typical of the wide use of locally made bricks in construction in and around Athens. These children seem to be enjoying themselves on a summer day. Notice the propped open windows in the house.

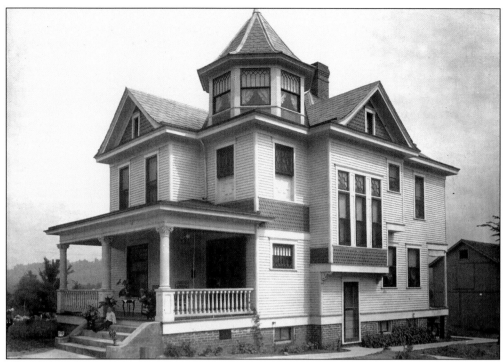

This absolutely stunning Victorian house was the home of John Hewitt, located at 26 Elmwood Place in the growing east side of Athens. The young man sitting on the front porch steps is Hewitt's grandson. Notice the presence of the carriage house situated conveniently just behind the house. After the introduction of automobiles in the 20th century, many of these interesting structures were either converted into garages or in some cases into guesthouses.

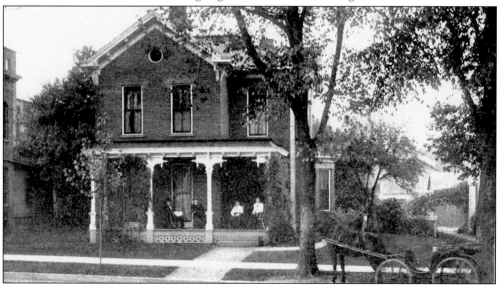

This photograph shows another example of the many fine brick homes that lined Athens's streets in the late 19th and early 20th centuries. An interesting feature of this photograph is the horse and buggy that is parked along the curb. It is the home of Henry O'Bleness on East Union Street.

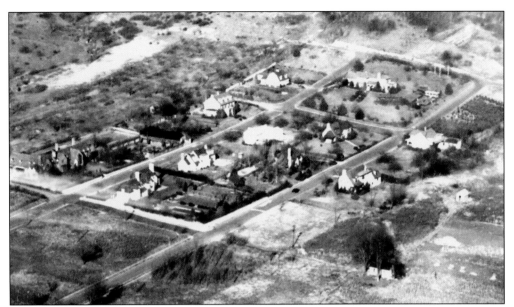

Between 1900 and 1920, the number of houses in Athens doubled. In order to meet the housing needs of a growing population the city expanded geographically as well. This early aerial photograph shows the first homes built on Utah Place and Strathmore Boulevard in the east side of town. The mansion on the lower left of the photograph was built by the Zenner's, early retail merchants in Athens, and was later occupied for many years by the Altman family. The home directly across from it was the longtime residence of the Rosenberg family.

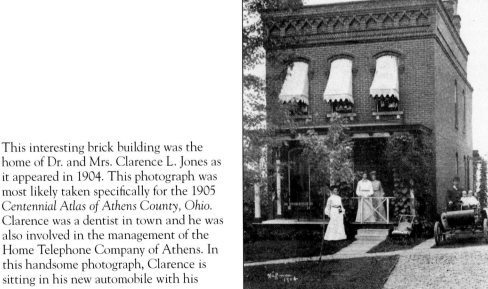

This interesting brick building was the home of Dr. and Mrs. Clarence L. Jones as it appeared in 1904. This photograph was most likely taken specifically for the 1905 *Centennial Atlas of Athens County, Ohio.* Clarence was a dentist in town and he was also involved in the management of the Home Telephone Company of Athens. In this handsome photograph, Clarence is sitting in his new automobile with his twin sons.

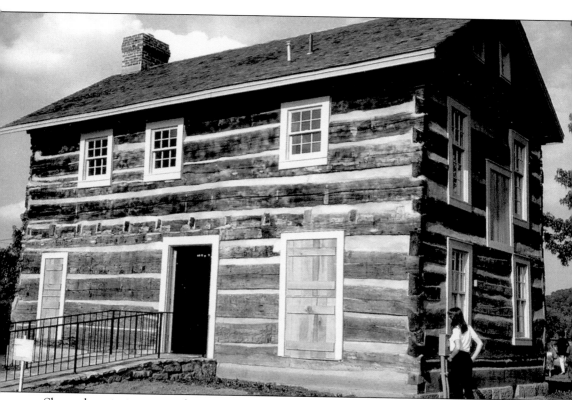

Shown here in its current location on the campus of Ohio University, the Bingham house is the oldest structure known to exist in Athens. Its builder, Silas Bingham, a Revolutionary War veteran, was at various times a mill owner and tavern keeper. He was very much involved in early Athens governmental organization, he was the village's first sheriff, and along with his brother Hiram, was one of the first settlers of Athens. Believed to have been built around 1806, the house originally stood on South College Street but was moved to an East State Street location in the mid-1800s. The house has had a long and fascinating history. It served as a tavern and inn, as the county's first courthouse, and as the residence of Robert Wilson, the third president of Ohio University. It was also the home of John Newton Templeton, the first African American graduate of Ohio University in 1828. The house has been restored and moved again to serve the community as a visitors' center. It is one of the few remaining two-story log structures in southeastern Ohio.

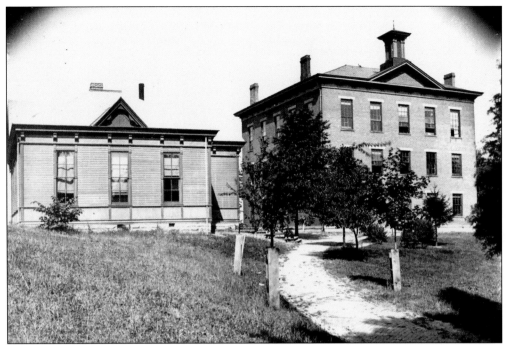

These are two of Athens's early public school buildings. The cottage, which served as a school from 1889 to 1908, is on the left and the school known as "Old Brick," 1857–1911, is on the right. Old Brick was one of the first public school building erected in Athens, and it served grades 1 to 12. They were located on the school hill on West Washington Street.

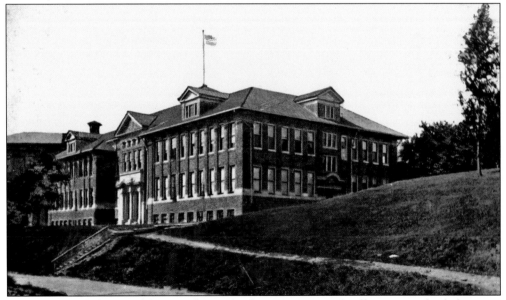

This stately and elegant edifice was the result of a community-wide effort to raise funds for a new school in 1908. It was built as a high school and was put up beside Old Brick and the cottage. The cottage was eventually removed from the site and Old Brick was torn down in 1911. In that same year East Side Elementary was built and Central Elementary remained on the hill. A new high school was opened in 1925, and this building became the junior high. It was torn down in 1980.

Located on the other side of the hill from the original high school building this new high school fronted West State Street and was opened in 1925. In 1968, a new high school was built off Route 33 in The Plains, and this building became the new middle school. It was extensively remodeled and some architectural features restored in 2000.

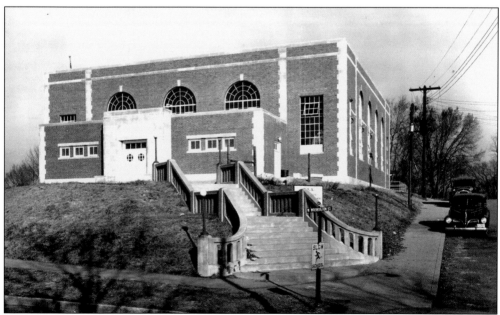

The scene of thousands of gym classes over the decades and the site of countless numbers of exciting basketball contests, the Athens gymnasium was opened in 1950. It was situated on the school hill complex at the corner of West Washington and High Streets. It continues to serve the physical education needs of the city's youth today.

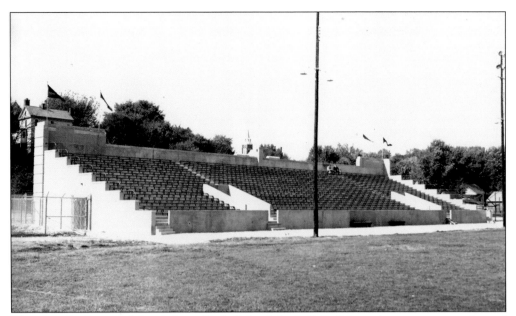

This was the home of the Athens High School football Bulldogs where two generations of Athenians played the game. Located just off Mill Street on Putnam Drive, the Athens football stadium, known originally as the City Recreation Field, was built in the 1930s by funds generated through Franklin Delano Roosevelt's New Deal. This photograph shows how it looked in 1939.

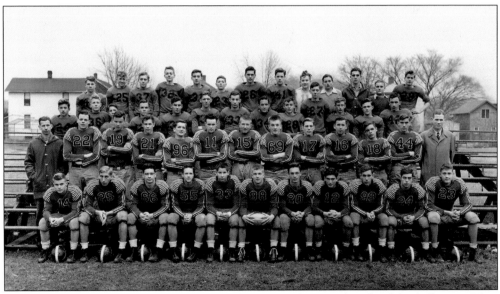

This fine-looking gang of gridiron heroes is the 1943 Athens High School football team. They were the champions of the Southeastern Ohio Athletic League with a record of eight wins and no losses. In their eight games they outscored their opponents by a collective score of 255 to 25.

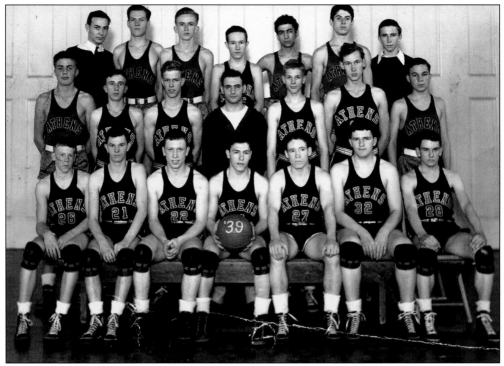

These young men are the members of the Athens High School varsity and junior varsity basketball teams of 1939.

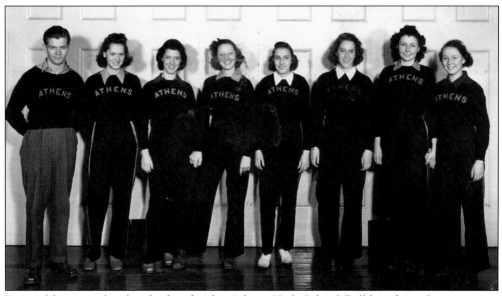

Pictured here are the cheerleaders for the Athens High School Bulldogs from the same year, 1939. Although they are not all identifiable, on the left in the photograph is Ray Rardin, fourth from the left is Ann Matters, and second from the right is Betty Mapes.

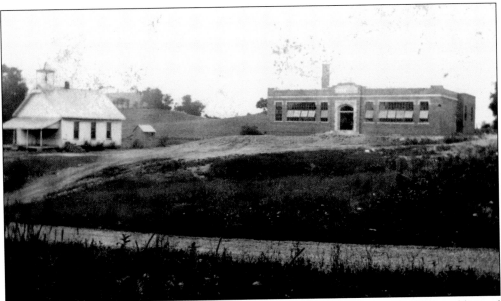

In 1923, as the population of Athens expanded, it became necessary to build an additional elementary school. West Side Elementary, pictured here alongside an older school or church building, was built on a hill overlooking Central Avenue. To meet the needs of an expanding school–age population, East Side Elementary had been built in 1911.

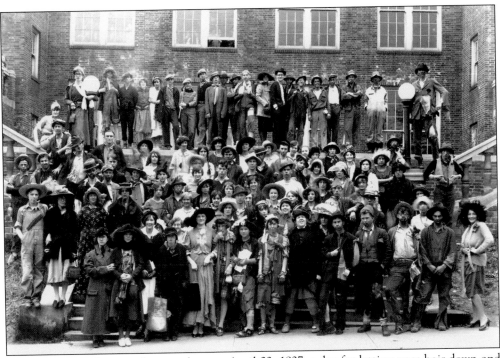

This intriguing photograph was taken on April 22, 1927, a day for letting ones hair down and forgetting the rules. Dressed in some truly outlandish costumes, students at Athens High School on West State Street celebrate Hobo Day, a tradition that has gone by the wayside.

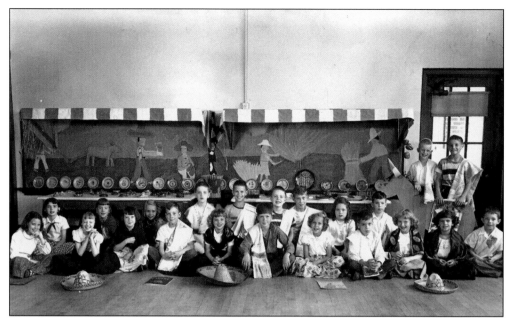

Mrs. Stauffer's third-grade class at West Side Elementary School in 1951 celebrates Mexican culture. Pictured from left to right are (first row) Sharon Coen, Sandy Antle, Amelia Conkey, Richard Dotson, Sue Hamer, Ray Bullock, Judy Hunter, Jimmy Dean, Sue Van Dyke, Karen Gilkey, and Melvin Pyle; (second row) Pam Daines, Judy Dean, Darlene White, Jim McMullen, Allen Young, David Wood, Robert Dotson, Carol Brown, David Straw, Ronnie McBride, and Ted Hutchins. (Courtesy of Dave Straw.)

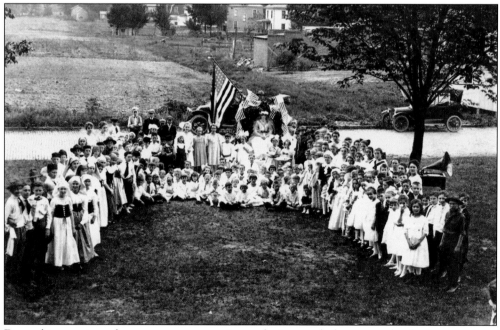

Dressed in a variety of costumes, some seeming to depict people from many lands, these students from East Side Elementary School in Athens are part of a May Day pageant and celebration held on the school grounds in 1930.

56

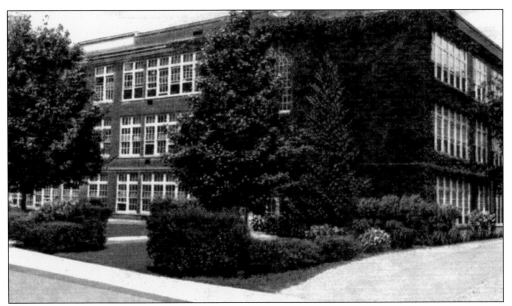

In addition to West, East, and Central Elementary schools in Athens, some Athens children had the option of attending Rufus Putnam School, which was operated by Ohio University as a lab school. It was located at the foot of Putnam Hill and was adjacent to the Athens High School football field. In 1926, Ohio University closed the John Hancock High School, which it had operated as a training facility, and moved teacher training into Putnam Hall. The school was closed in the early 1970s.

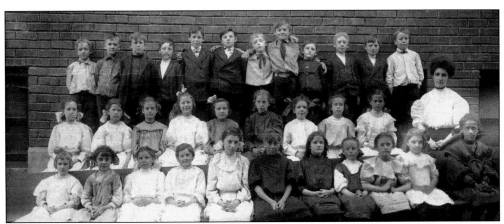

This captivating photograph from the late 1890s shows the fourth-grade class from the only elementary school in Athens at the time, the Central School, which was located on the hill above West Washington Street. Close examination of the photograph reveals some interesting details.

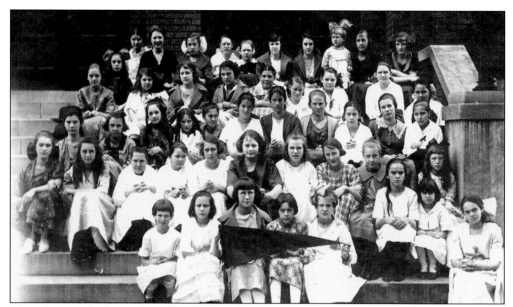

This photograph shows the Pollyanna Sunday school class on the steps of the First Christian Church on West State Street in Athens. Many of the girls in the photograph were from the Athens Children's Home. The young girl with the glasses in front holding the pennant is Pauline Fierce, who taught in the Athens schools for many, many years. Her sister Iris is the girl with the very large bow in her hair, third from the left in the back row. She also taught for many, many years in the Athens school system.

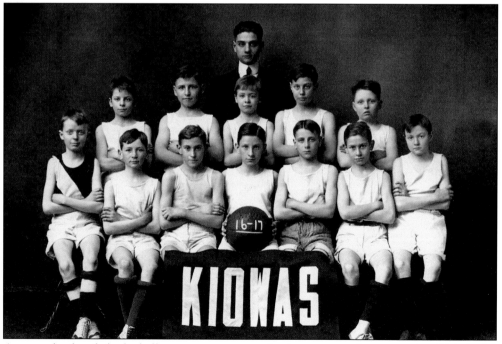

Apparently church basketball teams were as popular long ago as they are today. This is the basketball team from the Kiowas Sunday school class from the Athens Presbyterian Church shown in a team photograph from 1916–1917.

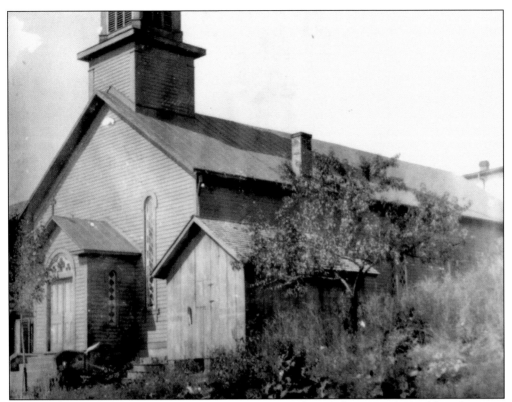

The first Roman Catholic congregation was organized in Athens in 1846, although it was 17 years before the group was large enough to build the first Catholic church in the town. This church, completed in 1863, was located on Congress Street and served the Catholic community of Athens for 32 years. When the new church was built, the Catholic congregation of Athens numbered approximately 200.

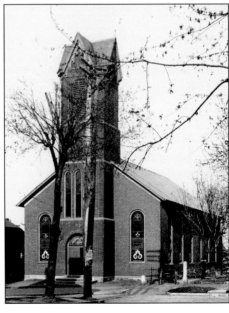

For 170 years, a Methodist church has stood proudly at or near the intersection of East Washington and College Streets. The one pictured here was built in 1837 and extensively enlarged and remodeled in 1861. In 1904, when this photograph was taken, membership in the church was approximately 750 adults with over 400 attending Sunday school.

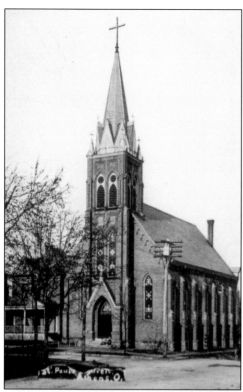

On May 12, 1895, several thousand people attended the laying of the cornerstone for St. Paul's Roman Catholic Church, which still stands on the corner of College Street and Mill Street in Athens. The church, with its 110-foot-high steeple, was dedicated on May 14, 1899, in a festive atmosphere that included a parade and the closure of all the town's saloons for the day.

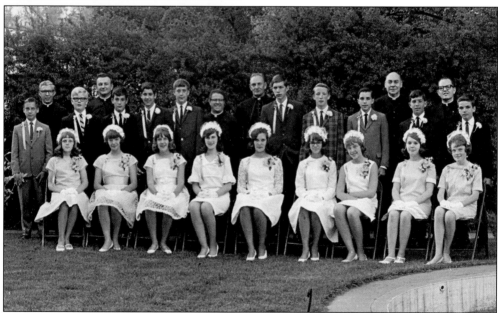

The Roman Catholic community in southeastern Ohio was large enough by the mid-20th century to support a school, and St. Paul's School, located behind the church in Athens, served students through the eighth grade. This is a photograph showing the eighth-grade graduation class of 1966. The priests, who represented the home parishes of the students, are, from left to right, Father Cronin, Father Patala, Father Gaudo, Monsignor Kish, Father Brisgal, and Father Maloney.

In 1905, the successful hotel owner Edward Berry purchased the lot at the northeast corner of Carpenter and Congress Streets and made it available for the construction of a new church for the congregation of the Mount Zion Baptist Church. The church was dedicated in September 1909, and it continues today to serve the spiritual needs of Athens's African American community as it has for nearly 100 years. The church is listed on the National Register of Historic Places.

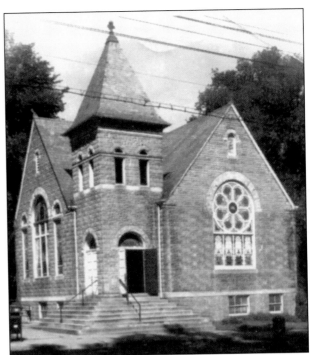

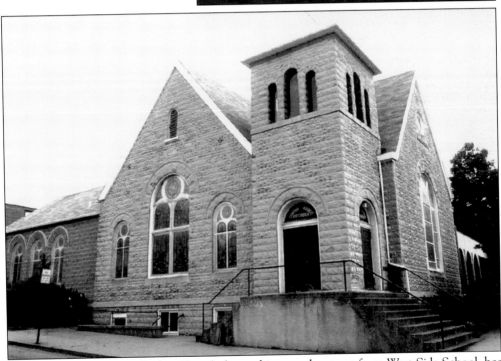

The Central Avenue Methodist Church, located just up the street from West Side School, has been a mainstay in the religious life of west side Athenians since its construction in 1909. The building was constructed of concrete block, which was a relatively new building material in the early 20th century. Several homes in the west side of Athens were also built from this material about the same time.

This is a 1918 group photograph of Jehovah's Witnesses from the Poston congregation in Athens. For many years their gathering place was a small wooden building on West Washington Street between Pratt and Maple Streets.

This is a 1917 photograph of a number of choirs gathered together at the First Christian Church in Athens. Pictured are the combined Children's Chorus of Athens, with their director, plus the Gilfilen Quartet and the Hatley Quartet. Singing conventions were a popular form of entertainment at this time.

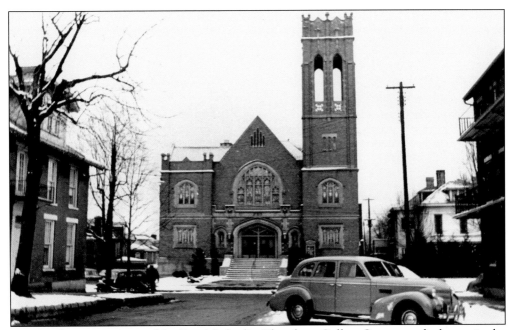

In 1900, the congregation of the First Methodist Church on College Street was the largest in the town of Athens. By 1905, a move was under way to build a new edifice suitable for a congregation of 700 and growing. By 1908, this beautiful church was completed and opened. It stood just south of the old church and faced directly up East Washington Street.

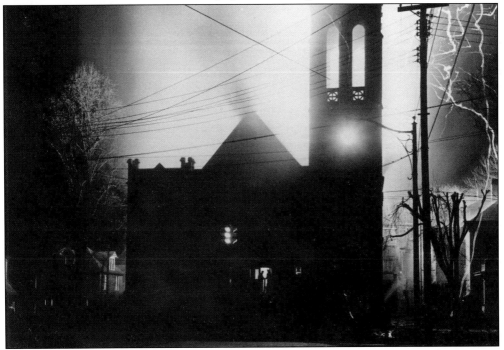

Athens has been plagued with fires over the years and none was more spectacular or tragic than the one that ravaged the First Methodist Church during the wee hours of the morning in February 1955.

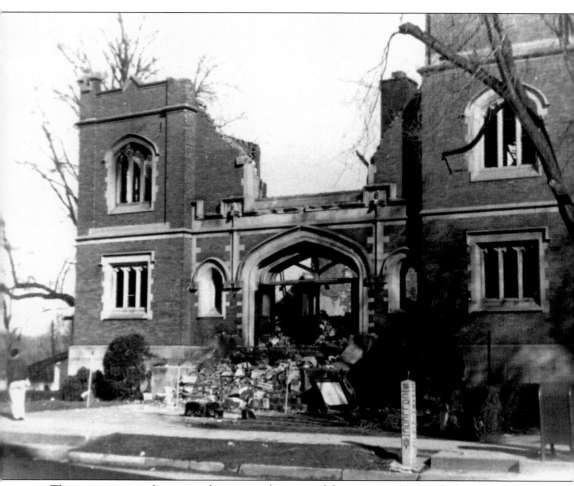

The next morning the city awoke to view the ruins of the once stately church that had occupied such a prominent place uptown from 1908 until 1955. The church was a total loss and the catastrophe was felt deeply by the entire community. The fire itself was a spectacular event and townsfolk awoke in the night to the sounds of the fire sirens. Many people made their way to the site of the conflagration to watch as firemen attempted to extinguish the blaze. Their efforts were to no avail, and as day broke it was clear that the church would have to be razed and rebuilt. It was a three-year process, but in 1958 the present beautiful church with its white steeple pointing skyward opened to widespread approval from the congregation and others in the city as well.

Four

THE RIVER

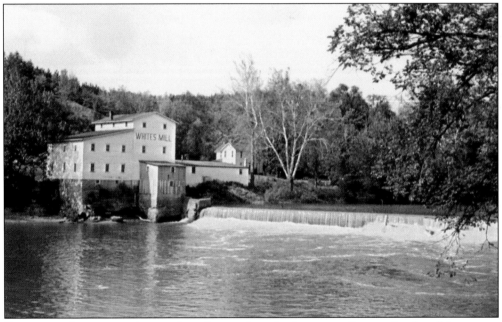

Rivers served transportation needs and were also a basic source of power for the all-important milling industry. Several mills were built along the banks of the Hocking River in the first century of Athens's existence. Until 1970, the Hocking River was not only a source of some beauty and bounty, it was also a feared element of nature that rose out of its banks on a too-frequent basis, destroying homes and businesses. White's Mill, located at the intersection of Routes 682 and 56 in the far west end of town, was opened in 1911 but stands on the site of a much older mill.

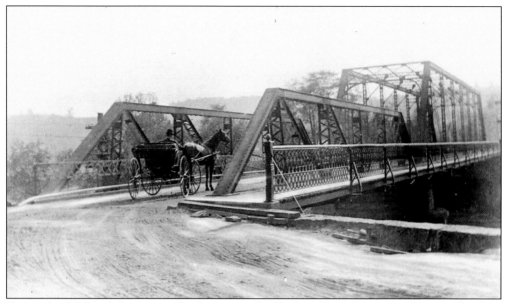

For much of Athens's history two bridges across the Hocking River have served the needs of the town's citizens. One bridge was located at the end of Mill Street where it meets the river and the other is the bridge pictured here, usually referred to as South Bridge, which spans the river along Richland Avenue. This bridge was originally a wooden covered bridge, but after the flood of 1907, it was replaced by this steel structure, and in 1932, the present-day concrete bridge was built.

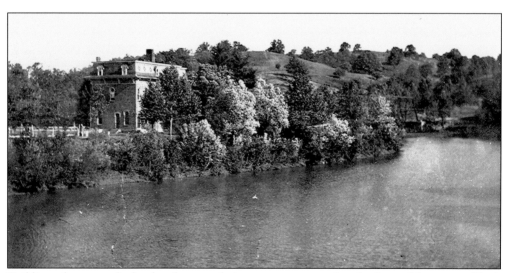

Building a home on the banks of a meandering stream can produce both good fortune and bad. The location can seem idyllic but the river can be a threat. On a site along the Hocking River near the present-day location of White's Mill, this lovely home, which was built by Athens entrepreneur Joseph Herrold, stood from the 1870s until 1913.

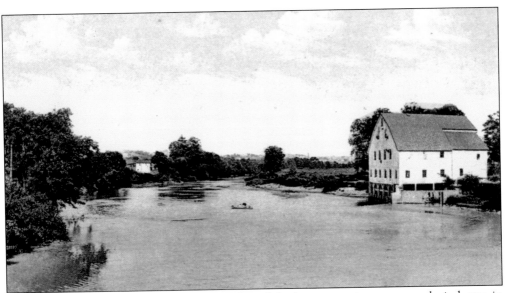

Mills, to produce fabrics, cloth, flour, meal, and feed, were an important early industry in river communities like Athens. Pictured in this photograph is Herrold's Mill, which was built originally by Silas Bingham in 1816. It was taken over by Herrold in 1840 and operated until 1912 when it burned. It was located on the approximate site of present-day White's Mill.

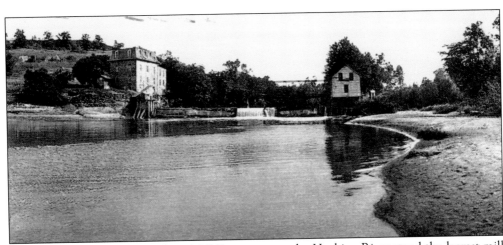

On the east side of Athens where Mill Street crosses the Hocking River stood the largest mill in Athens, known as Stewart's Mill. It was a combination woolen mill and flour mill and was built in the mid-19th century by Daniel B. Stewart, an early Ohio capitalist who also laid out the village of Stewart, Ohio.

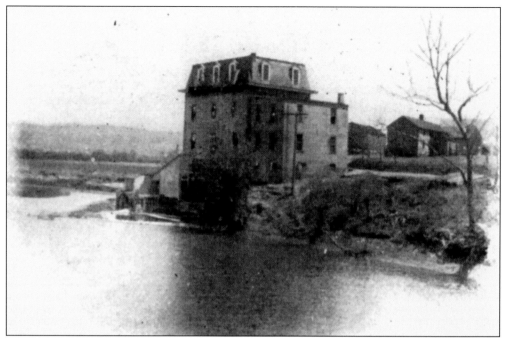

While the writing on this photograph identifies it as "Stewart's Mill, Athens," Robert Daniel, in his excellent book *Athens, Ohio: The Village Years*, identifies it as Otto Barth's Mill and Dam. The photograph is from around 1907. There had been a mill on this site along the Hocking River in Athens since 1806.

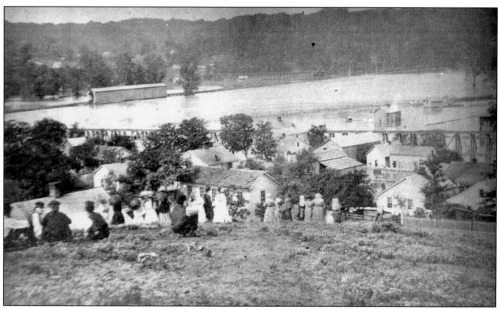

The devastating floods that plagued Athens from the years of its earliest existence have always attracted widespread attention, both from those seeking solutions to the problem and those who simply want to witness the ravages of Mother Nature. In this photograph, possibly from 1873, a large number of Athenians turn out to witness the spread of the floodwaters over the south end of town.

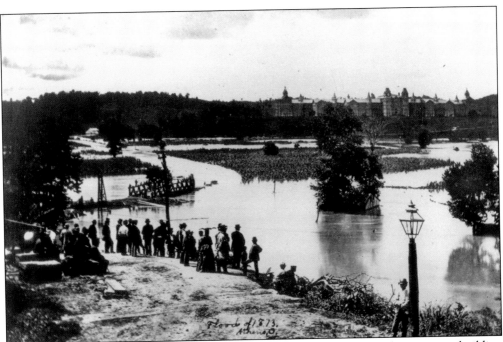

Although it will not open officially until the following year, the massive administrative building of the Athens Asylum is visible in the background in this photograph of the 1873 Athens flood. While it was not the most destructive flood in Athens's history, this one did considerable damage to the growing village.

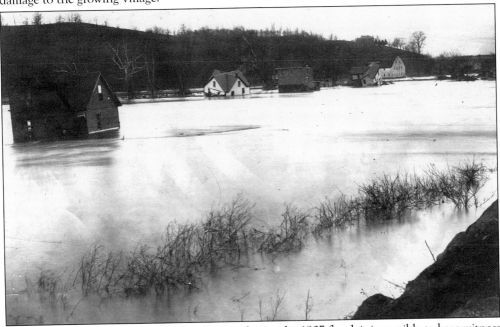

In this photograph of the rushing floodwaters during the 1907 flood, it is possible to bear witness to the mighty power of the river and its potential for utter destruction. This scene depicts the floodwaters in the west side of town along West Union Street. Herrold's Mill, which would burn in 1912, is in the background.

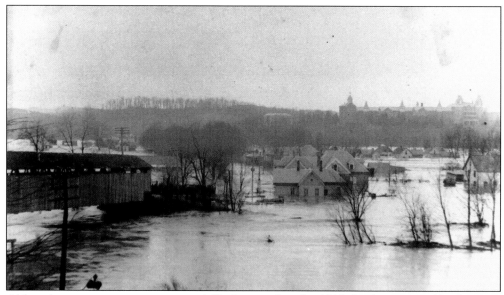

Although accurate comparisons are difficult to make, the 1907 flood was arguably the most damaging to ever occur in Athens. This photograph shows the floodwaters at their highest point, engulfing the Richland Avenue area. The covered bridge was destroyed in the flood and would be replaced the next year with a modern steel structure.

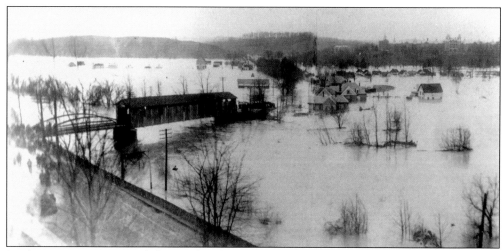

In this panoramic view of the south side of Athens the extraordinary extent of the river's destructive power is visible. The 1907 flood would, when it was all over, claim seven lives and destroy the South Bridge and Otto Barth's Mill and Dam. Otto Barth died in the flood while attempting to save others.

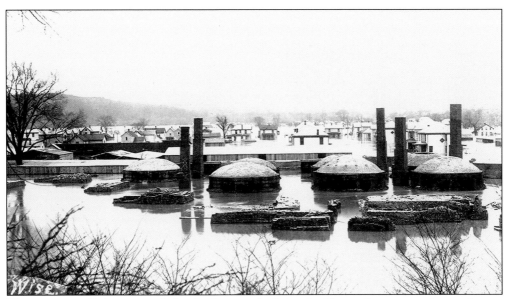

There were well-documented floods that resulted in significant damage or destruction to property and that seriously affected life in Athens in 1832, 1847, 1858, 1873, 1907, 1913, 1937, 1940, and almost yearly throughout the remainder of the 20th century until the Army Corps of Engineers moved the river in 1969 and eliminated the majority of the damage caused by floods along the Hocking River. The floods of 1964 and 1968 were two of the last that caused significant damage and they were particularly severe in the extent of the damage they caused to university property. In the mid-20th century, many residents of Athens remembered March 14, 1907, as one of the worst days in Athens's history because of the disaster that resulted from the rampaging floodwaters. No part of Athens that was within reach of the rising torrent was spared, and the damage to homes and businesses was on a grand scale. Besides the damage done to property, seven lives were lost in the flood, and as a result of the efforts of some to rescue others, 17 Carnegie Medals for Heroism were awarded. The extent of the damage the disastrous flood of 1907 caused is illustrated in these two photographs, which show parts of the east end under water as well as the completely inundated Athens Brick Works.

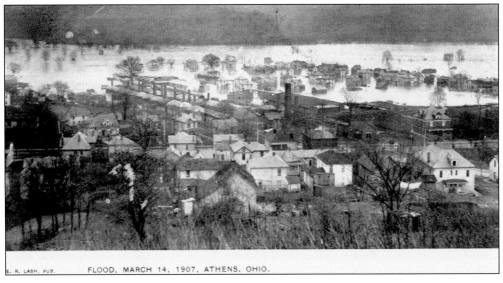

E. R. LASH, PUB. FLOOD, MARCH 14, 1907, ATHENS, OHIO.

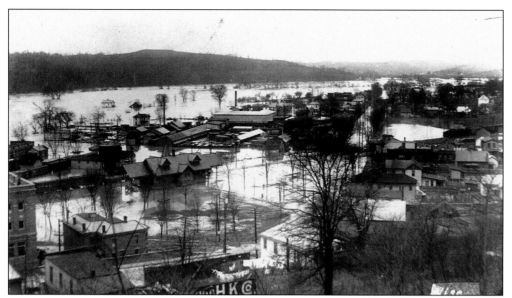

During periods when Athens was flooded, transportation in and out of the community was seriously affected since train traffic would be halted. In this photograph of part of the west end of town in 1907, more damage from the March flood of that year is visible. This photograph was probably taken from a vantage point on West Washington Street. The train station is clearly visible surrounded by water as is the Athens Lumber Company's buildings. In the 1907 flood, residents of the city were without safe drinking water for at least a week.

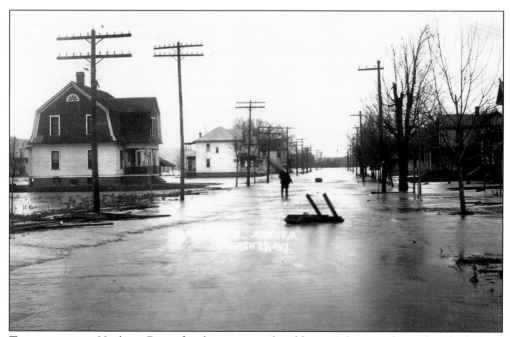

To some extent Hocking River flooding was predictable in Athens and people joked about the spring flood season. Heavy March rains were the culprit and 1913 was no exception. This photograph shows the floodwaters running down Morris Avenue on March 27, 1913.

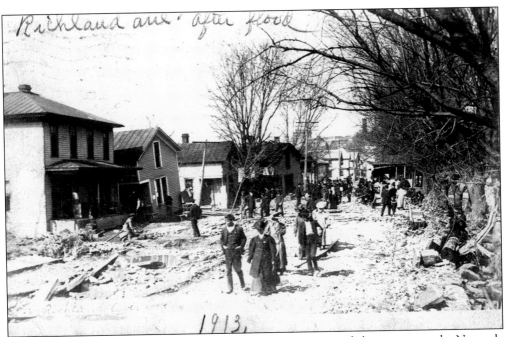

The aftermath of a devastating flood left an immense amount of cleaning up to do. Not only were many, many homes damaged beyond repair, as is evident from this scene along Richland Avenue after the March flood of 1913, but debris of all sizes and types was strewn everywhere the raging waters flowed. Richland Avenue was one of the most vulnerable areas of town and its residents were among the first to be evacuated as the river's waters rose.

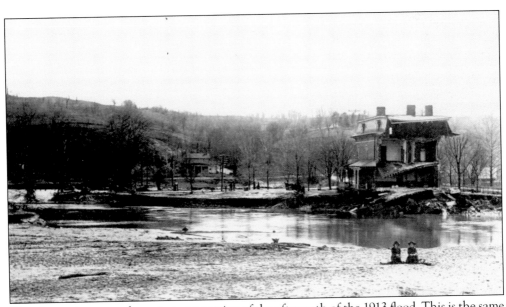

This depressing scene shows just one portion of the aftermath of the 1913 flood. This is the same lovely home pictured on page 66 but here showing its utter destruction as a result of the power of the floodwaters. The two women sitting so poignantly in the foreground are unidentified.

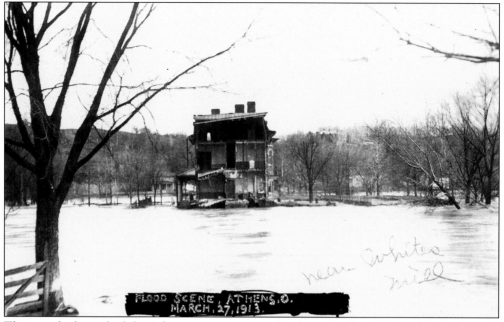

This was the home built by Athens entrepreneur and industrialist Joseph Herrold, which stood close to the present-day site of White's Mill. By 1913, when the flood undermined the homes foundation and completely destroyed it, the showplace was owned by the Brickle family.

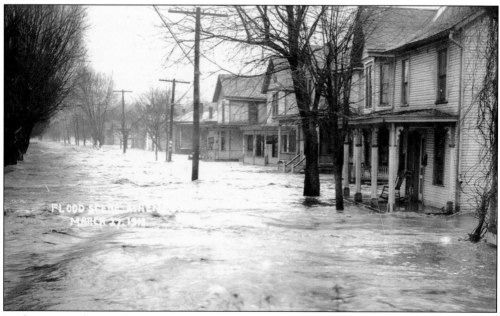

In this extraordinary photograph, the photographer seems to be in the middle of the rushing waters, perhaps in a boat. The appearance of the water as it gushes along West Union Street is indeed formidable, bubbling over porch floors and lapping at the front doors of these homes.

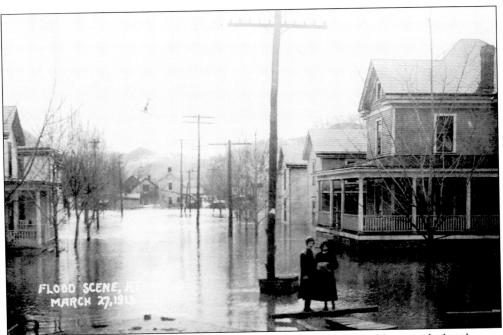

FLOOD SCENE,
MARCH 27, 1913

Other than surveying the damage and wondering when they might be able to reach their homes, it is difficult to imagine what these two young women are doing in this photograph. The 1913 flood did most of its damage in the vicinity of West Union Street, and as this photograph attests, many homes were completely inundated and impossible to get to.

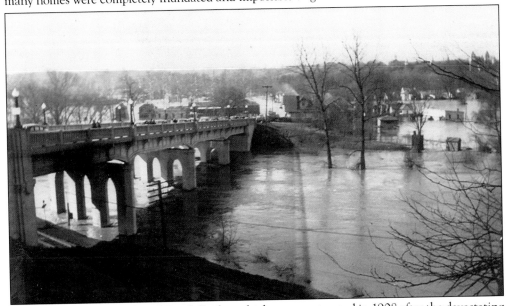

In 1932, the old iron and steel South Bridge, which was constructed in 1908 after the devastating flood of 1907 destroyed it, was replaced by the modern concrete span shown in this 1940 photograph. While the bridge itself was never damaged by floodwaters it ceased to serve its historic purpose as a span over the Hocking in 1969 when the river's course was altered. The area under the bridge has been recently developed by Ohio University and it is difficult to see any remnants of the Hocking River's longevity there.

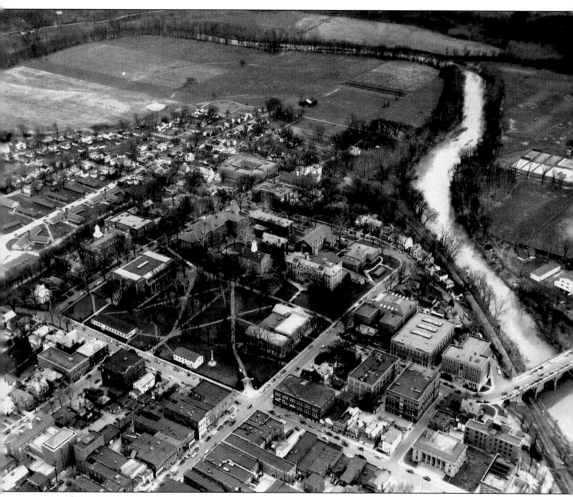

In this 1950 aerial view of Athens, much of the southern half of the city is visible. It is difficult to discern from this photograph that the older part of the city sits upon a bluff overlooking the river. Hence, the college green and the uptown portion of Athens were never threatened by the Hocking River's floodwaters. But as the river meanders around Athens the land stretches out in a flat and spacious flood plane that made for excellent agriculture but that also was primed to receive the overflow from the river's banks following heavy spring rains. Many landmarks of mid-20th-century Athens are clearly visible in this photograph, from the South Bridge in the lower right corner of the picture to the central post office building, to the college green. Close examination also reveals the old Masonic hall on the corner of East Union Street and College Street and some of the fine homes that still stood along these two streets as well as in other parts of uptown.

Five

OHIO'S FIRST UNIVERSITY

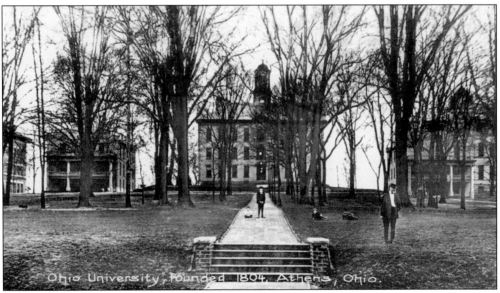

Lindley, Putnam, Cutler—these are names that are familiar to anyone with even a passing interest in the history of Ohio University. Founded in 1804, it was the first public institution of higher education chartered in the Northwest Territory and the first in the state of Ohio. In this view from about 1908, looking from East Union Street into the college green, a few of the earliest university buildings are evident. From left to right, Ellis Hall is just barely visible, and then there is the building known then as the East Wing, the College Edifice, the West Wing, and on the far right partially hidden is Ewing Hall.

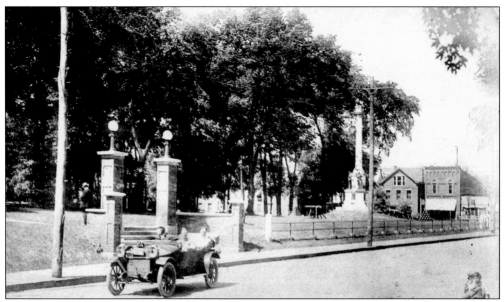

Perhaps out for a Sunday drive these three men stop in front of the new campus gate to get a good look at the campus. Donated originally by the class of 1912, this portal was the main entrance into campus until the Alumni Gateway was constructed in 1915. The Class Gateway, which occupies this site today, was donated by the class of 1949 and built in 1960.

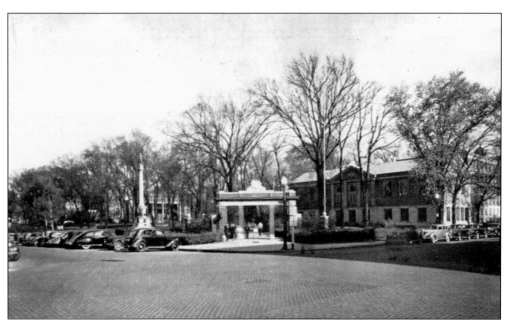

The Alumni Gateway, at the corner of the college green at Court and Union Streets, was a gift from the graduating class of 1915 to honor the memory of the university's first graduating class 100 years earlier. The quotations on the archway were taken from a Latin inscription found on the main gate at the University of Padua, Italy.

The inscription that greets people as they enter the campus through this gate reads, "So enter, that daily thou mayest grow in knowledge, wisdom, and love." As one leaves the campus the inscription reads, "So depart, that daily thou mayest better serve thy fellowmen, thy country, and thy God."

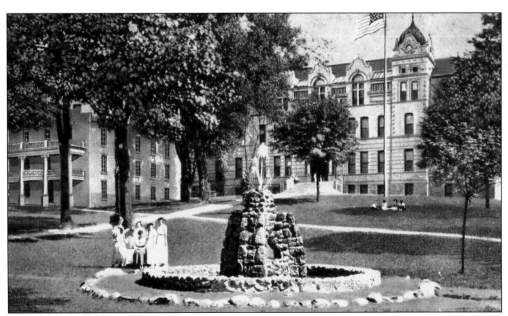

While Ohio University has been an institution that has taken a great deal of pride in its heritage and worked diligently to preserve much of it, some things have been lost forever. In this photograph from 1916, a landmark known as the Bird Fountain is seen in front of Ewing Hall.

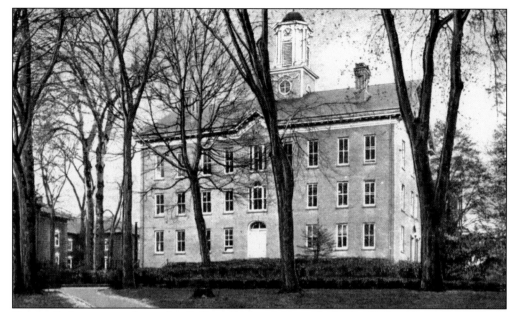

Originally known simply as the College Edifice, Manasseh Cutler Hall is the centerpiece of the college green, and its image is synonymous with Ohio University. Begun in 1816, it was the first building constructed in the Northwest Territory devoted to the pursuit of higher learning. Over the years, it has been used as a dormitory, classroom building, laboratory, library, and museum. Since the 1950s, it has housed administrative offices. After World War II, it was saved from demolition and restored to its original appearance. In 1966, it was designated a national historic landmark.

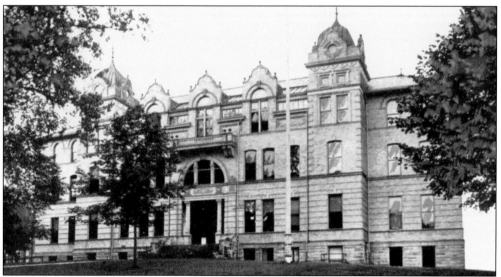

Ewing Hall, shown here in 1907, was for much of its life the largest and most important building on campus. Named for Thomas Ewing, one of the first graduates of Ohio University in 1815, it was built in 1898 under the tutelage of Pres. Charles William Super who persuaded the state legislature to provide funds for construction of a classroom and administrative building. Ewing Hall contained not only classrooms and faculty and administrative offices, but also an auditorium that seated 1,200 people.

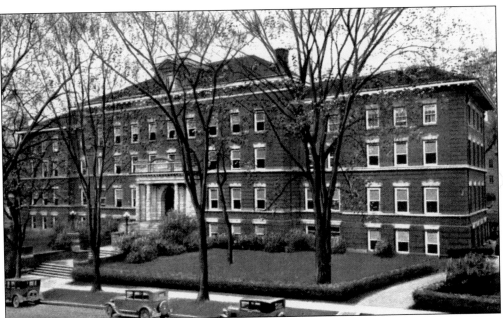

Constructed originally as the Ohio State Normal School, Ellis Hall was the first university building paid for entirely by state funds. Begun in 1902, with additions added in 1906 and 1908, it was, when completed, one of the institutions largest classroom buildings. It was built with the purpose of instructing teachers, and over the years, it housed both the Model School and the John Hancock High School, both teacher training schools.

Located just behind Cutler Hall, on the site now occupied by Alden Library, this ivy covered building served the university for many decades as a chapel, as a music classroom building, and as a fine arts hall.

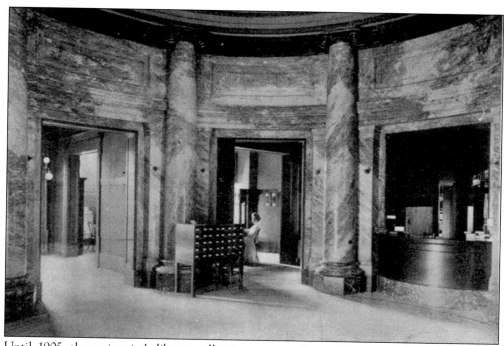

Until 1905, the university's library collection was not housed in its own building but was forced to share space in Cutler Hall. In that year, as part of his ongoing philanthropic efforts, the Pittsburgh industrialist Andrew Carnegie donated $30,000 to the university to construct a separate library. Although it was a part of Ohio University, the yellow-brick building was designated a free library and was consequently open to all the residents of Athens for their use.

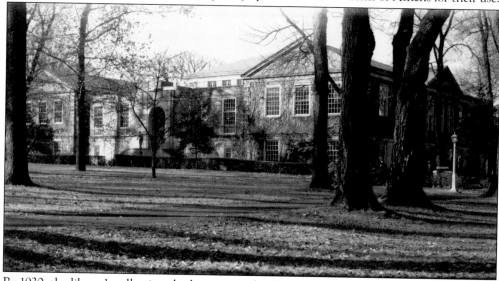

By 1930, the library's collections had outgrown the Carnegie Library and the university moved to build a larger one. The Edwin Watts Chubb Library, shown here in 1949, opened in 1931 and served as the institution's main library until the Alden Library opened in 1969. Chubb Library was named in honor of Edwin Watts Chubb, who served the university as professor, dean, and acting president. In 1969, the name was changed to Chubb Hall and the building was converted to office space.

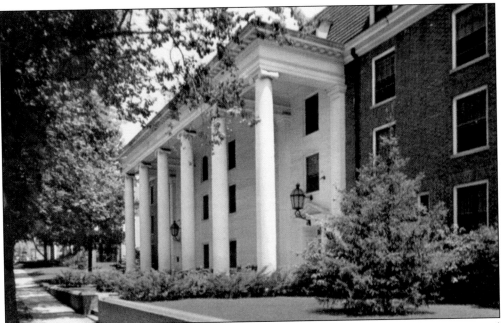

In 1913, President Ellis created the position of dean of women to deal with many special concerns of the growing number of female students at the university. Irma Voigt would serve in that position until 1949 and leave an indelible mark on the university. Among her many accomplishments was the establishment of student government at the university. Voigt Hall, with it columned exterior and hotel-like lobby and public areas, was constructed in 1954 and originally housed 150 women.

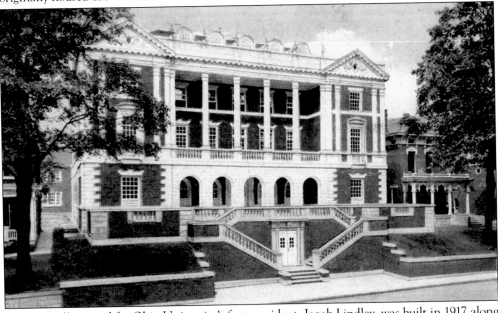

Lindley Hall, named for Ohio University's first president, Jacob Lindley, was built in 1917 along a block of South Court Street near Park Place. It also was constructed as a dormitory for female students and as their numbers increased the building was expanded, first in 1939 and later in 1951.

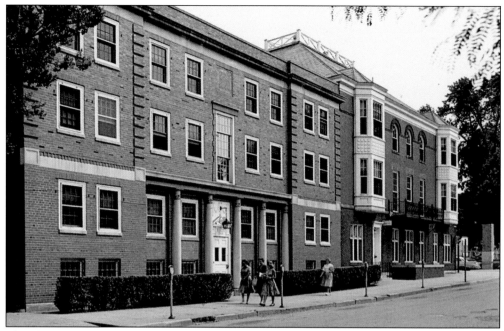

The oldest of the university's dormitories for women was Howard Hall, located on the corner of College Street and East Union Street, shown here in this photograph from the 1950s. It opened in 1896 with a restaurant and shops on the ground floor and rooms for 30 women on the second. It was operated privately until the university bought it in 1908. It was demolished in the 1970s, and today the parklike setting that remains is a popular meeting place for students.

Summer terms at the university were an innovation of the early 20th century that brought more and more women to campus. This photograph shows a group of summer school students gathered on the steps in front of Boyd Hall in 1911.

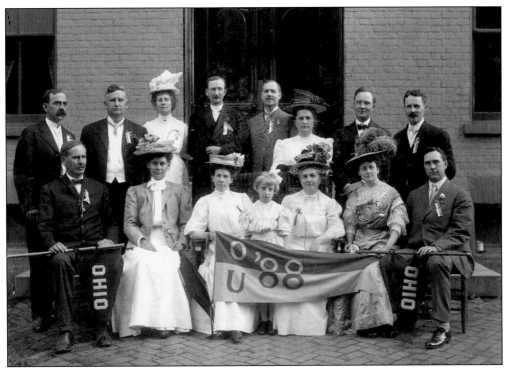

In 1872, the Ohio University Alumni Association was founded and it began to host reunions soon thereafter. In this photograph, possibly from 1908, members of the class of 1888 pose with Ohio pennants.

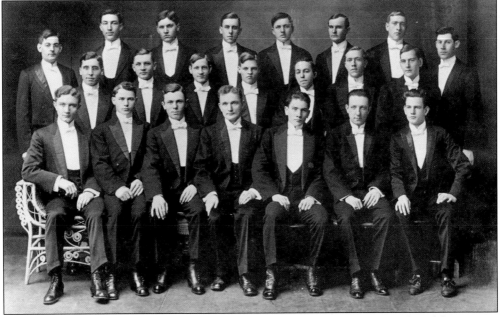

At the beginning of the 20th century, and stretching well into the 1920s, glee clubs were an extremely popular extracurricular activity on the campuses of America's colleges and universities. In this undated photograph, the Ohio University Men's Glee Club is pictured.

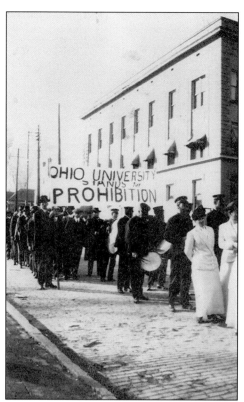

Ohio University students have had a long history of involvement in social and political activism stretching from the 19th century to the present. In the late 19th century into the first two decades of the 20th, the movement to enforce prohibition was the main reform concern that attracted public debate in Athens. In this photograph from around 1912, a parade of temperance supporters winds its way through the streets of Athens.

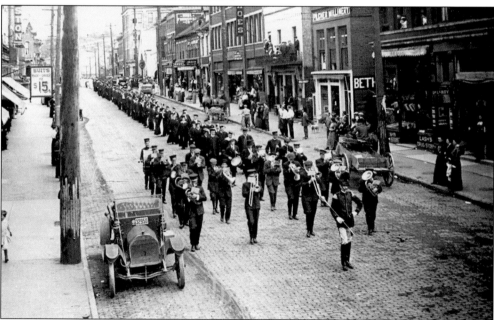

Images like the one depicted here evoke a time that is so different from now while illustrating customs that are still a part of everyone's lives. In this June 1915 photograph a parade of Ohio University graduates marches down Court Street behind the local band while well-wishers look on from the sidewalks.

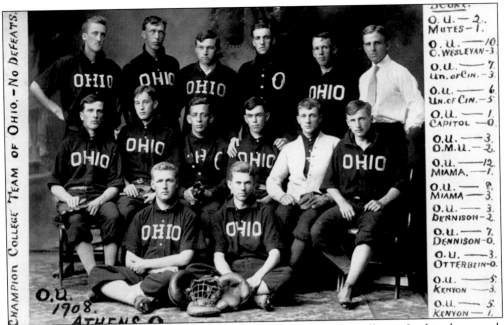

Ohio University has a long and distinguished history of baseball excellence. In this photograph the proud members of the undefeated 1908 Ohio University baseball team are shown. They were, as the photograph states, the "Champion College Team of Ohio—No Defeats."

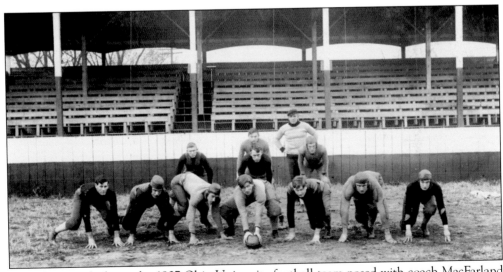

This photograph shows the 1907 Ohio University football team posed with coach MacFarland in front of the stands at the old university athletic field, which was located across the street from the site of the Convocation Center.

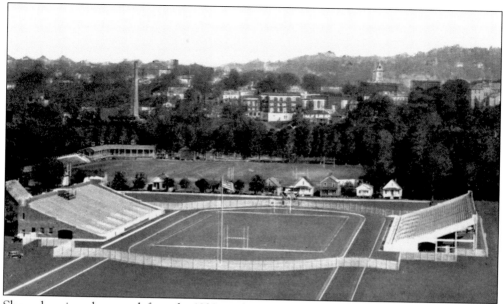

Shown here in a photograph from the 1930s is what was known at that time as the Ohio University Athletic Plant. The football stadium was built in 1929 and seated 12,000. Over the years, the stadium has been altered and enlarged and it currently has a capacity of 24,000 spectators. The stadium was eventually named in honor of Don C. Peden, one of the legends of Ohio University athletics. Peden was a coach and athletic director over a 27-year career at Ohio, and he was one of the founders of the Mid-American Conference.

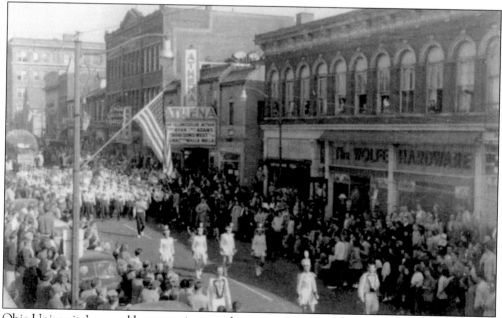

Ohio University's annual homecoming parade was an eagerly awaited event each fall in Athens. On a Saturday morning in October hundreds of students and townspeople alike lined the sidewalks of the streets uptown to watch marching bands, floats, and of course, the candidates for Homecoming Queen parade by. This 1952 photograph gives a look at the Ohio University Marching Band on South Court Street.

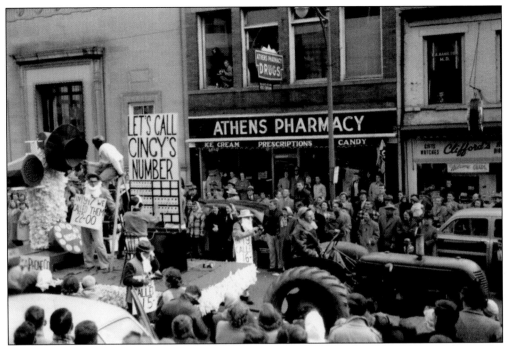

In this photograph of a float from the 1949 homecoming parade, the size of the crowds and the creativity of the student organizations in designing floats that reflect their desire to defeat the opposing team are evident. In the game that afternoon unfortunately Ohio University got a wrong number when they placed their call to Cincinnati. Final score: Cincinnati 34, Ohio 13.

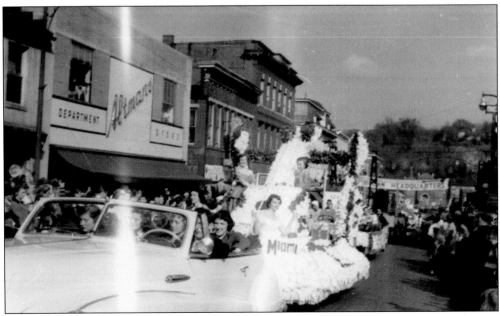

The pomp and elaborate displays on the floats upon which the queen candidates rode are shown here in this photograph from the 1952 parade. For many years in the 1950s and 1960s, the usual opponent for Ohio in the homecoming game was their archrival, Miami University.

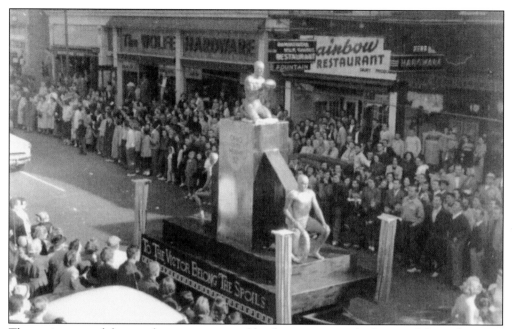

The excitement of the parade was accentuated by the many ornately decorated floats that were built by nearly every student organization on campus. The rules that governed the creation of the floats were stringent and the competition between groups was fierce. This is the winning entry in the men's category in 1952. It is the float from the Tau Kappa Epsilon fraternity.

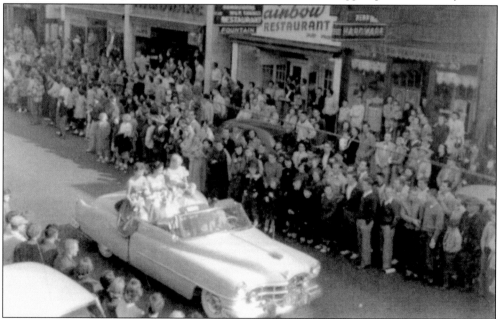

The Ohio University homecoming parade was an elaborate and ritualized event that wound its way throughout uptown Athens and lasted well over an hour. The highlight of the affair for many was the arrival of the newly crowned Homecoming Queen and her court. Here is the 1952 queen and her court riding up South Court Street in front of the Rainbow Restaurant and the Kerr Hardware store.

Six

THE ATHENS ASYLUM

In one way or another, whether economic or social, from 1874 to the present the institution known variously as the Athens Lunatic Asylum, the Athens State Hospital, the Athens Mental Health Center, and the Ridges has occupied a significant place and exerted considerable sway over the city of Athens. For most of its history the elaborately and beautifully landscaped grounds served the needs and pleasures of not only the patients of the asylum but Ohio University students and townspeople alike. The number of buildings increased along with the patient population and in 1900 there were 961 patients there. By 1926, the number had reached 1,500.

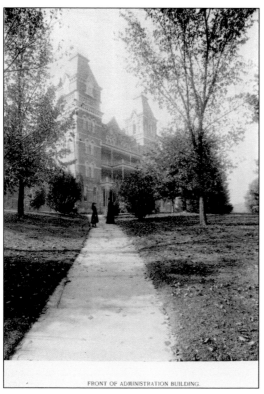

In 1867, a group of Athenians purchased over 1,000 acres of land from the Coates family and donated it to the state as the site for the new asylum the legislature was considering for southeastern Ohio. The cornerstone of the administration building was laid in November 1868 amid an elaborate ceremony that included members of many town organizations as well as marching bands and choirs. The image pictured here is one of many included in this work that comes from a unique set of photographs of the asylum, produced by the Baker Photogravure Company of Columbus in 1893.

FRONT OF ADMINISTRATION BUILDING.

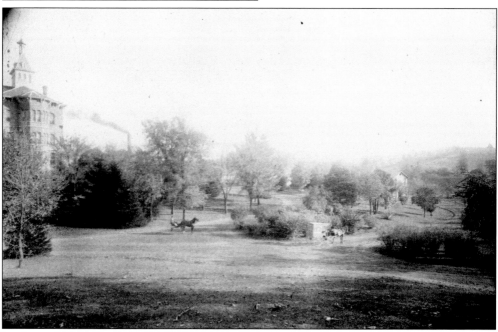

In the mid-20th century on Sunday afternoons it was quite typical for Athens families to take slow drives through the asylum grounds and perhaps stop for a picnic. This pastime dates back even into the late 19th century as Athens residents looked upon the hospital grounds as a public park.

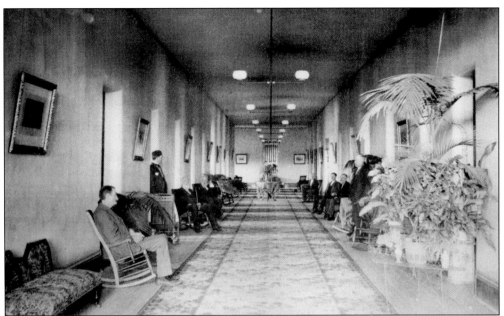

The main architect of the asylum was Thomas Story Kirkbride, a noted designer of large institutional structures during the last quarter of the 19th century. Part of the design philosophy that he employed reinforced the contemporary belief among medical professionals that patients in a mental health facility would benefit from an atmosphere that more resembled a home and in which they could freely move about and socialize with both staff and other clients. The commodious surroundings displayed in these photographs were located in the central administration building but they were reserved for the most passive and quiet patients. In the 1880s, according to Robert Daniel, the decision was made to separate the more violent patients from the quiet and passive ones, a move that resulted in the expansion of the facility. The men's and women's wings pictured here reflect the homelike atmosphere that was sought after as a therapeutic tool.

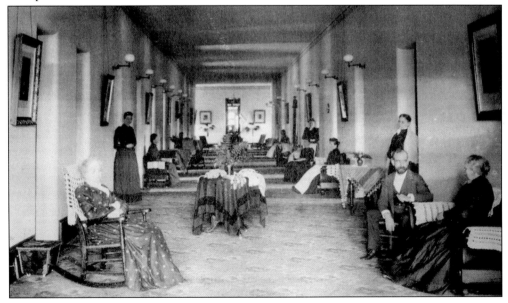

Throughout the history of the hospital, the exquisite grounds were never off limits to some of the patients. Exercise in the open air was considered to be an important aspect of their therapy. In this 1893 photograph some of the men are walking on the grounds with their doctors.

Sadly in this era of limited knowledge about mental illness, few patients received much care beyond basic sustenance and exercise. Mental institutions were used as a last resort to house many of society's unwanted, especially the elderly, and once committed to a place like the Athens Asylum, the majority of patients stayed for the remainder of their lives.

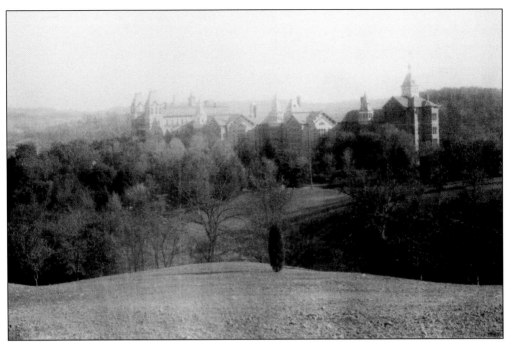

As the number of patients increased in the 1880s, the number of buildings that were constructed to house and treat them expanded as well. By 1893 the patient population was over 800 and the complexity of the institution, as illustrated by this photograph, reflects this growth. The buildings are impressive and ornate and could be those of a college or university nestled among the hills and tree-covered hillsides.

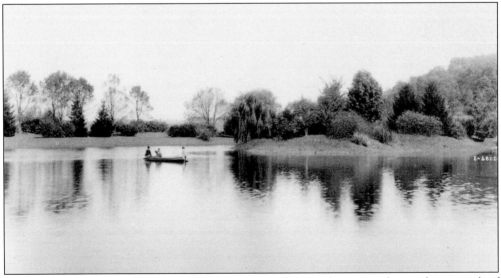

One of the most beautiful and enchanting aspects of the asylum grounds was the network of ponds and the acres and acres of exquisitely sculpted gardens and grounds that were completely free and open for the public to enjoy. For decades the people of Athens and the surrounding area enjoyed the grounds as if it were a wonderful park and not a hospital. The landscape design was created by Herman Haerlin, a student of Frederick Law Olmstead, who was the most innovative landscape architect of the late 19th century.

The asylum was built in a naturally beautiful location but much was added to enhance its appeal. The landscaping philosophy that Herman Haerlin employed encouraged the manipulation of the environment to create an inviting setting. The hospital grounds were a treasure trove of bird species and tree and shrub varieties and it was used as an outdoor laboratory by Ohio University professors who identified over 70 species of trees and shrubs and over 120 different varieties of birds on the grounds.

The ponds and lakes on the grounds were connected by a series of waterfalls and cascades.

As part of their therapy, many patients were free to walk the lanes and participate in recreational activities like boating. For much of its life span the hospital was able to supply most of its needs through the farm, orchard, greenhouse, and power plant that were on the grounds. Many of the workers in these operations were patients as it was considered an important part of their therapy to stay active.

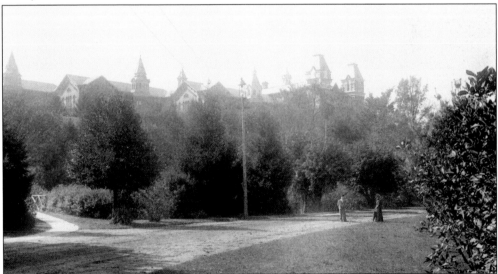

Today a view such as this of the main administrative building would be impossible to achieve. Following World War II, therapeutic philosophies began to change and large institutions such as the Athens Asylum, which had largely confined and managed the patients' lives, grew more and more irrelevant. As a result patient populations began to decline and the size of the grounds shrank. By the 1970s, the last of the ponds and much of the remaining land was taken for the new river course and the highway bypass.

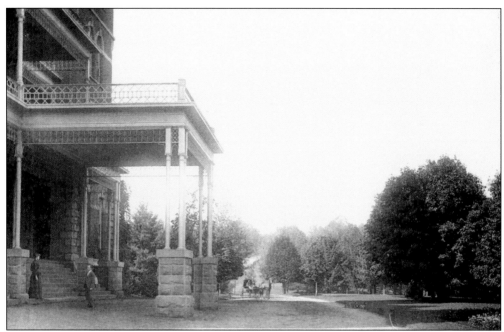

It is easy to look at photographs like these of the tranquil, lush, and almost idyllic setting that enveloped the asylum and forget the sadness and many individual tragedies that accompanied life there for thousands of individuals who, once committed, never left. According to Athens historian Robert Daniel, hospital records indicate that in any given year of its existence only about 20 percent of the patients were ever discharged as recovered and about 20 percent of them were eventually readmitted. It was indeed a heartbreaking place enclosed in great natural splendor.

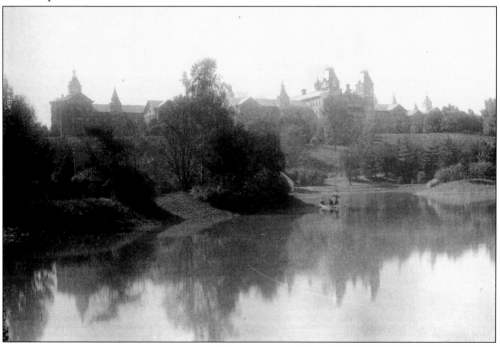

Seven

PEOPLE AND PLACES AROUND TOWN

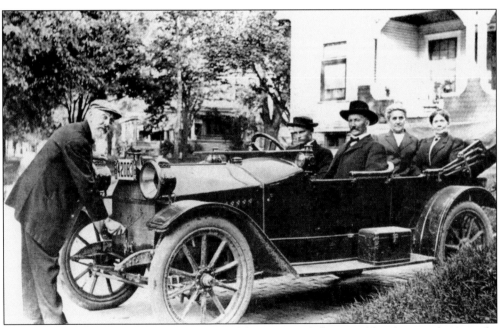

Cornwell's Jewelry is the oldest family owned business in Athens and has been in business for well over 100 years. In this delightful photograph from 1912, David Cornwell, founder of the Cornwell Jewelry enterprise, is starting his Ford automobile and posing for the camera at the same time. The other individuals in the car are unidentified but most likely they are Cornwell family members since the photograph was taken in front of their home in Athens.

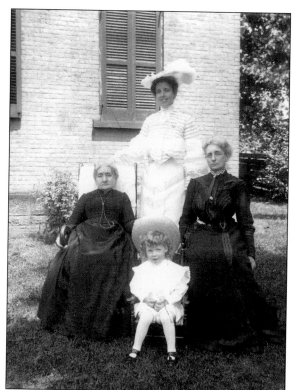

Black-and-white photography, while it is so effective at conveying mood and a certain tenor to a photograph, hides from the viewer the colors of the past. One can only guess at the shades and hues of these beautiful dresses. From left to right are Susan Putnam, Sarah Putam Norton, and Alberta Norton Ridenour. The boy is Richard Ridenour. They are seen in the yard of Susan Putnam's house on President Street in 1900.

Sometimes a photograph is just so poignant and so evocative that it must be included in a collection such as this. All that is known is that this little girl is from Athens and that she is dressed for a very special occasion. Have little girls really changed that much?

In the years before World War I, the temperance movement was especially strong in Athens. In November 1915, the dry forces in Athens brought the noted orator and three-time presidential candidate William Jennings Bryan to the village to speak out in favor of prohibition. In this scene he is giving forth a speech in front of the newly constructed Alumni Gateway on the Ohio University College Green.

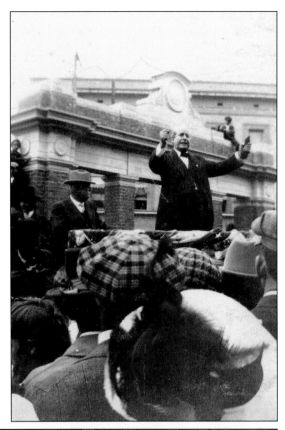

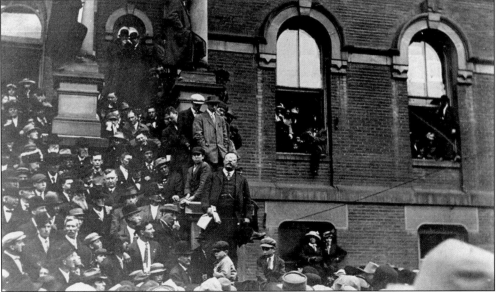

While Athens was far from an important political plum in the early 20th century its easy access due to the railroads that passed through the village made it a simple and convenient stop on the campaign trail. In this photograph taken May 19, 1912, Theodore Roosevelt speaks to a sizable crowd from the courthouse steps during his Bull Moose campaign.

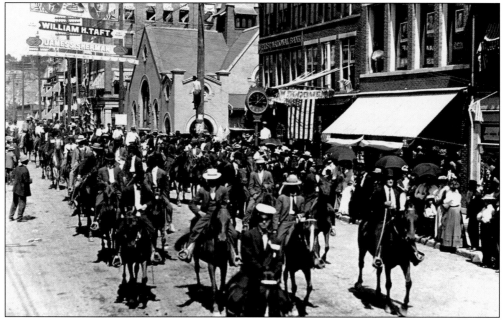

Pres. William Howard Taft, himself from Ohio, made at least two visits to Athens, once during the presidential campaign of 1908 and another in 1916. On a hot day at the end of August 1908, Athens welcomed the presidential candidate with a spectacle of patriotic fervor. Banners and flags festooned Court Street businesses and people were literally climbing the lampposts to catch a glimpse of Taft.

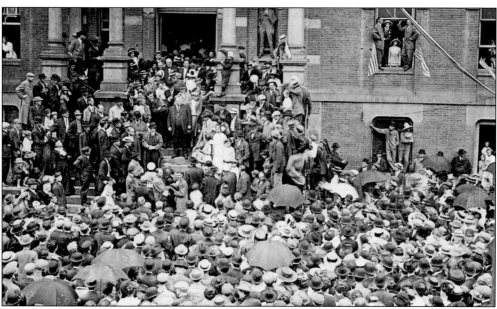

On August 28, 1908, Republican presidential candidate Taft gave a speech at the university and also spoke from the steps of the courthouse to a very large crowd assembled on the sidewalk and on Court Street. Close examination of the photograph reveals a surprisingly large number of women present and also reporters standing close to the candidate who are taking notes.

In 1916, the venerable Civil War general and congressman Charles H. Grosvenor hosted William Howard Taft at his home on University Terrace in Athens. Pictured also is Lawrence G. Worstell, an attorney and associate of Grosvenor. Worstell would become president of the Athens National Bank in 1917.

This intriguing and redolent photograph of an unidentified driver and young boy in the rear driveway of the Poston home on Park Place is suggestive of the wealth and privilege this coal baron's family enjoyed. Someone left the broom outside though.

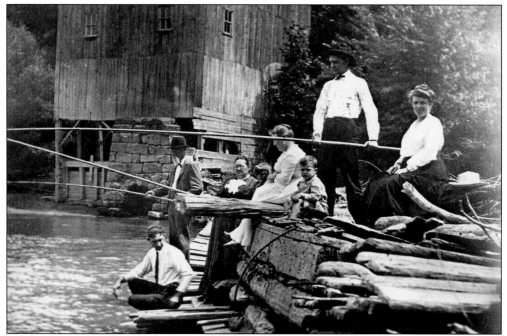

This is an evocative and perfect period photograph of a family fishing from the remnants of the Stewart's Mill and Dam at the end of Mill Street in east Athens. The individuals are not identified.

The dresses and hats worn by these young ladies are certainly attention-grabbing and suggest that these women were quite fashion conscious and up-to-date in their tastes. One wonders about the colors of the clothes. The group photograph was made in a quiet spot on the Athens Asylum grounds around 1910.

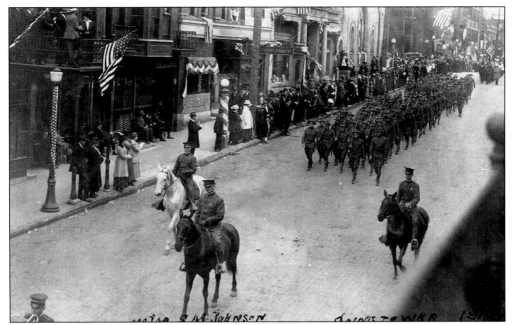

America's entry into World War I in April 1917 prompted an outpouring of patriotic sentiment throughout the country, and Athens was no exception. In all, 1,700 Athenians would participate in the armed forces during the conflict. Maj. Samuel L. Johnson, an Athens attorney, shown here leading a parade of Company L of the Ohio National Guard, was a certifiable war hero. Because of his efforts during the war in France he received the United States Distinguished Service Cross, the Croix de Guerre, and the Legion of Honor from the French government. Despite the writing on this photograph other evidence suggests the date of this parade as April 1917.

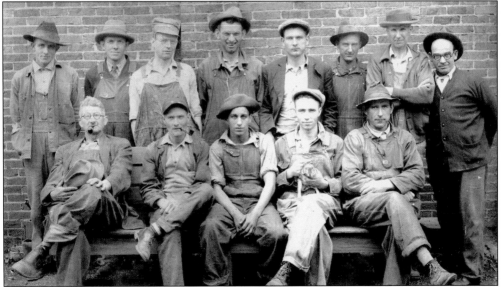

Starting in 1896, the Athens Lumber Company supplied the building needs of local construction companies. These are some of the employees of the firm, pictured in this group photograph taken on October 28, 1928. The reason for the photograph is not known. Look carefully to find the rabbit in the image!

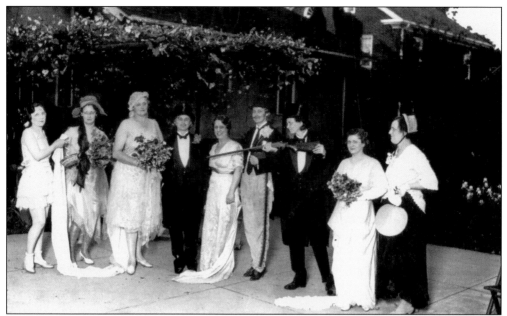

On May 29, 1932, the *Athens Messenger* ran a story with the unlikely headline "Depression Party Provides Much Merriment Saturday." The occasion was an elaborate costume party hosted by several women at the home of Mrs. N. T. Hoover on Elmwood Place. The group pictured here arrived as a shotgun wedding party. The bride is Mrs. R. W. Finsterwald, the groom is Mrs. A. B. Wells, and the father of the bride (with shotgun) is Mrs. Hampton Beeson. The party included humorous readings and songs and an elaborate dinner concluded the evening.

W. N. Alderman, pictured on the right, was one of the scions of Athens businessmen for several decades. He had financial interests in several important Athens establishments including banks, the Athens Lumber Company, a foundry, and the brick works. The younger man on the left is Franz Woodworth, who was president of the Athens Brick works. Woodworth was mayor of Athens from 1942 to 1947.

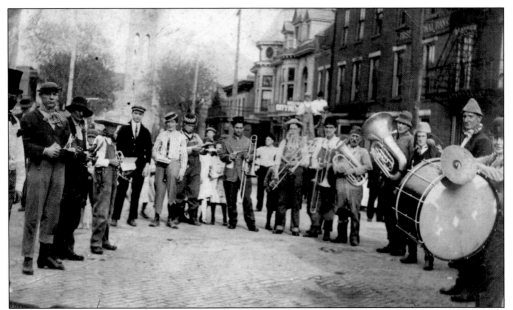

This photograph, along with a number of others presented in this volume, indicates a propensity of Athenians for silliness and general raucous behavior. There is no indication of what the occasion was for the community band to gather in front of the Presbyterian church but it must have been fun.

This individual is pictured in many photographs leading parades and celebrations of several varieties along Athens's streets. He is shown leading the band on several occasions and he is at the head of the procession of Ohio University graduates pictured on page 86.

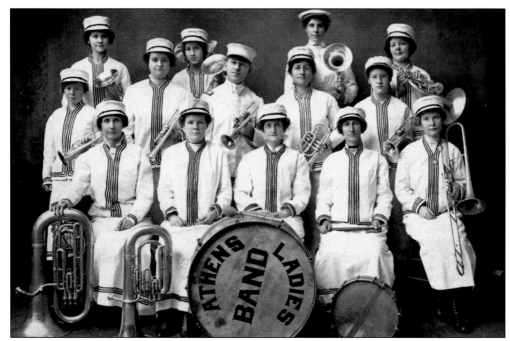

Taking their cues from the many regimental bands that accompanied troops during the Civil War, community bands such as these pictured here showed a penchant for brass instruments, although woodwinds were sometimes added, and favored military-style marches and popular sentimental tunes of the era. In Athens they played concerts on the college green and participated in many community events and parades. They were present at the dedication of several Athens churches and marched with the graduates of Ohio University during their annual commencement day parade. These photographs are from around 1915.

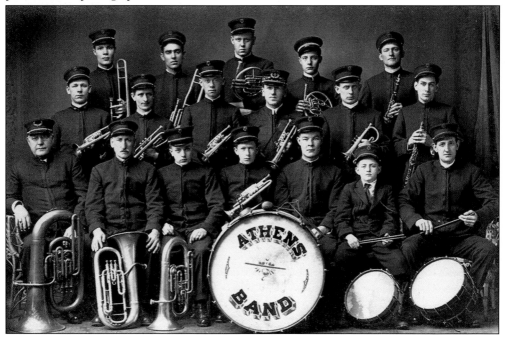

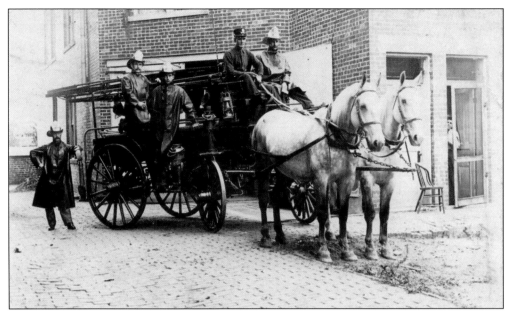

As villages grew to become towns, fires became a major concern. Athens got its first motorized fire truck in 1918, but until then response time to fires was very slow, and once at the fire, efficiency was marginal. Peter Finsterwald, the town marshal, is seated on the left. Dick and Frank, the two horses the fire department acquired in 1912, are pictured here beside the firehouse on East Washington Street.

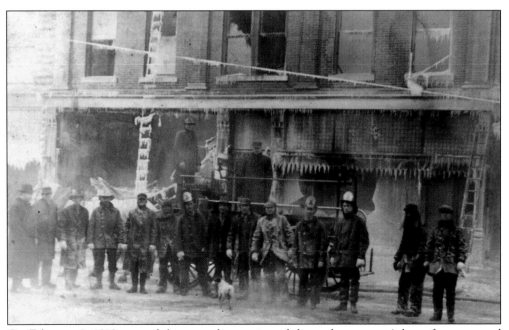

On February 9, 1912, one of the most devastating of the early uptown Athens fires occurred when the Cline Building, which housed Cline's Drug Store and Ice Cream Parlor, nearly burned to the ground. After the fire, only the exterior walls remained. Cline rebuilt, and the store was a mainstay on Court Street for decades to come.

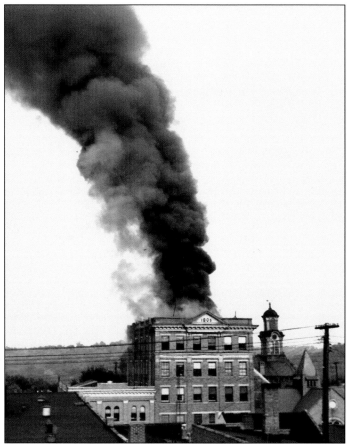

These two photographs show the fire at the Athens National Bank building in 1944. The Athens National Bank opened in 1905 in the first floor of a new five-story building, which was the tallest building in town. Various professional offices occupied the other floors, and the fifth floor was reserved for the Eagles Lodge. At the time it was built it was the most modern building in Athens, complete with an elevator, gas, and electric lights. Although the photographs of the fire are spectacular, the damage was confined and the building was not radically altered as a result.

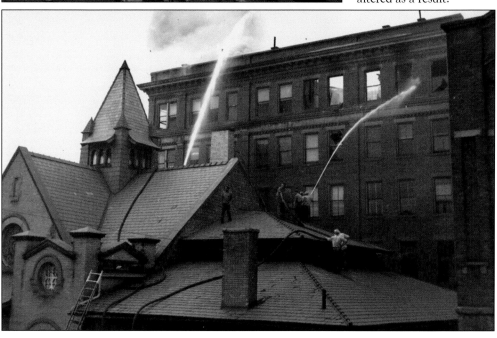

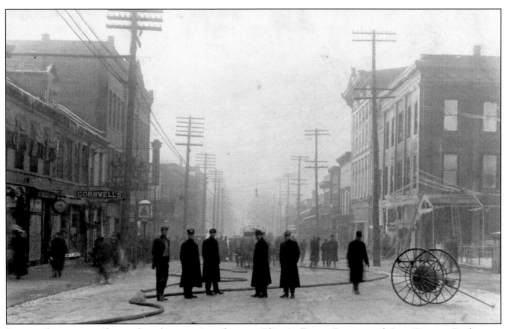

In another scene from the devastating fire at Cline's Drug Store and Ice Cream Parlor on February 9, 1912, it is apparent that the building is a total loss. The aftermath of the blaze found people standing and staring at what had been one of the favorite places of business in town.

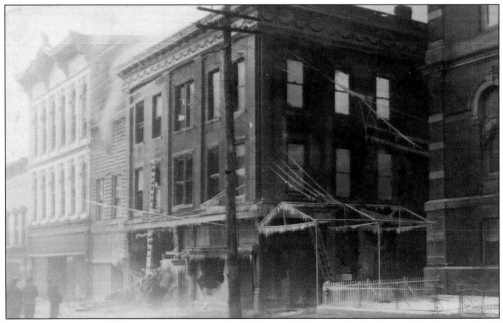

In this photograph it is easy to see the effects of the cold winter temperatures on the firemen's ability to handle the flames. Ice has formed on all the surfaces and smoke damage can be seen on the adjacent building. J. H. Cline would pick up the pieces and rebuild his business.

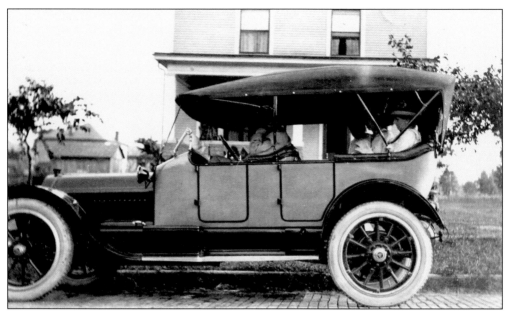

Pictured in this fine automobile in front of 62 Elmwood Place are Ohio University president Dr. Elmer Burritt Bryan and Mrs. Bryan, and T. N. Hoover and Mrs. Hoover. Elmer was president of the university from 1921 to 1934.

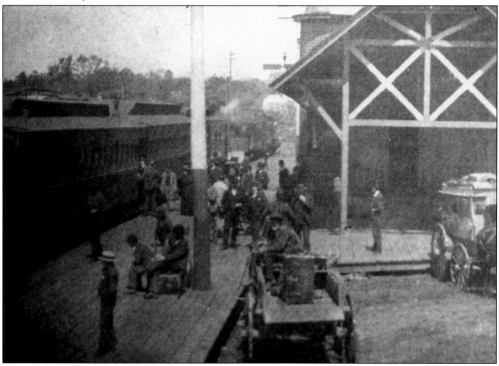

Waiting for a train, either to catch it or to retrieve someone who had just come back to town, was, and still is in some places, an exciting and much anticipated event, especially in a small town. There is a great deal of activity at the depot on Union Street in this photograph from around 1890.

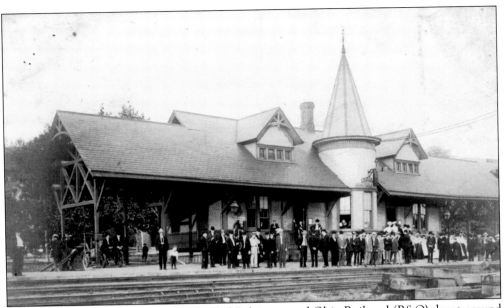

This is the newly remodeled and expanded Baltimore and Ohio Railroad (B&O) depot around 1904. It was generally known around town simply as the union depot because of its location off West Union Street. It was primarily a passenger depot.

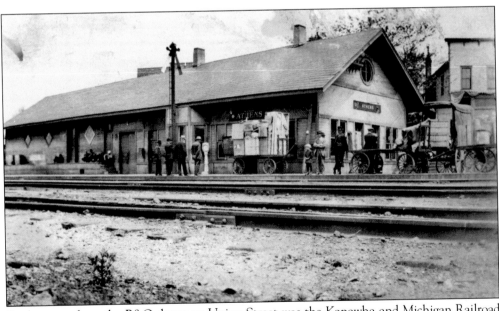

Farther west from the B&O depot on Union Street was the Kanawha and Michigan Railroad freight and passenger depot, located on the corner of Cemetery Street (now Shafer Street) and Dean Avenue (now West Washington Street). Trains from this station could take passengers from Athens to Columbus and back in a single day. By the 1950s, this depot had become the B&O freight depot and all passenger trains stopped at the Union Street depot. This photograph is from about 1904.

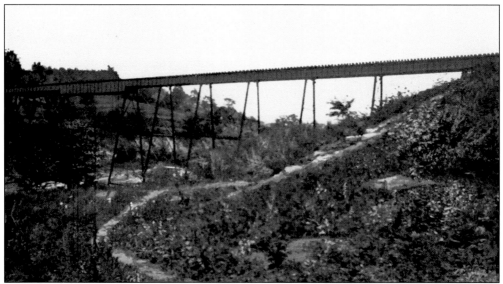

In the first decade of the 20th century, the business and economic community of Athens attempted on several occasions to secure financing to build an interurban or traction railroad line that would connect Athens with the many outlying coal camps in order to bring people to Athens to shop. It was not until 1915 that this plan was fulfilled, and even then it was not a complete success. The line connected directly to Nelsonville for the 45-minute trip, but in Athens, passengers arrived at the end of Central Avenue on the west side of town and had to be carried to Court Street in hacks and carriages. The trestle shown in these photographs was very near the terminus of the line at the bottom of the Second Street hill. Passengers could wait for the line and purchase tickets in a small building, which is still there. It is well-known in the west side as Frank's Bait Shop. Never profitable, the electric railroad was a thing of the past by the 1930s.

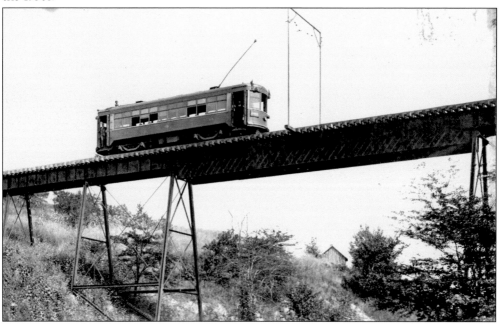

The charm of a train station at night is hard to overlook. Both the loneliness and the anticipation of a train's arrival can be felt in this 1930s photograph of the Union Street station in Athens. Scenes of sad and hopeful departures to war or college, and arrivals by students and businessmen throughout its history were played out here daily as they were in nearly every small town and city in the United States for over 100 years.

The era of steam engines lasted until the 1950s when they were replaced by the great diesel-powered locomotives, like the one pictured here facing west at the Union Street depot. By the end of the 1970s though, railroad traffic had dwindled to almost nothing, and by the early 1980s, not only were the trains themselves gone, even the tracks had disappeared. Other than a few shops and restaurants and an empty station, there is little evidence of the once-bustling railroad activity that characterized and defined much of Athens.

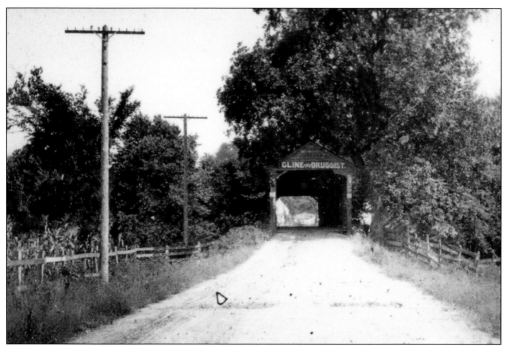

In this appealing photograph from about 1900, one can see an early form of outdoor advertising. The words "Cline the Druggist" are written above the entrance to the covered bridge advertising Cline's Drug Store in Athens.

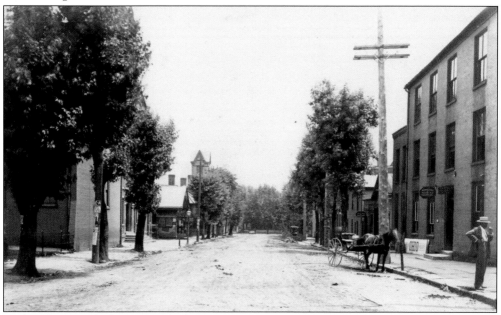

In this photograph the scene is looking east on West Washington Street towards the corner of College Street. Unlike much of uptown, so much has changed from this photograph that it is nearly unrecognizable from the same spot today. The photograph is from before 1908, since in the center background is the steeple of the Methodist church that was replaced in that year. The street is unpaved and shows evidence of the main problem that resulted from horse traffic.

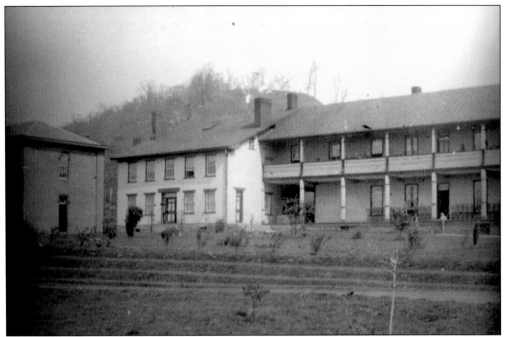

The Athens Children's Home opened in 1881 on 125 acres of land off East State Street about a mile outside the town's boundaries. In 1905, when this photograph was taken, it was, like the Athens Asylum, a nearly self-sufficient administrative unit that included a farm, barns, large gardens, living quarters, and even a school. In 1916 this structure was replaced with a large brick building with imposing columns in the front. The school closed in 1940, and the institution itself was gone by 1970, torn down to make way for the new Route 33 bypass.

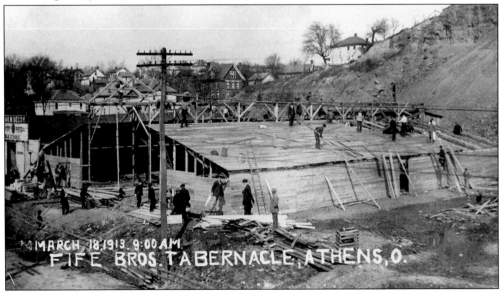

In a huge outpouring of community effort and determination, this very large building was constructed in one day, March 18, 1913. It was built to support the revival held in Athens by the Fife Brothers and it seated approximately 2,000 people. It was built at the foot of "shale hill" near the corner of Court and Carpenter Streets, just about where the armory is located today.

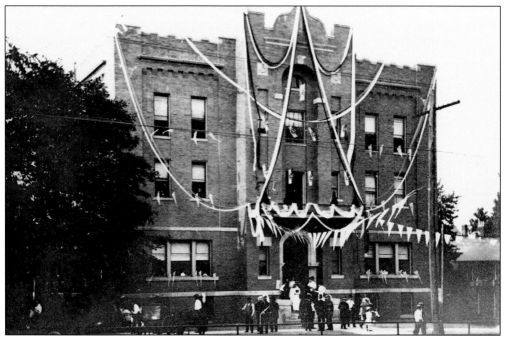

This imposing structure, festooned with patriotic flags and bunting, was the old Masonic temple, which was built in 1910 on the corner of East Union Street and College Street. It was purchased by Ohio University in the 1920s and used as a student social center. It was demolished in 1951 to make room for the construction of Baker Center.

The Palmer House, a smaller version of its namesake in Chicago, was considered by many to be the most fashionable hotel in Athens for many years. It was located on the southeast corner of West Washington Street and Congress Street, where the building still stands.

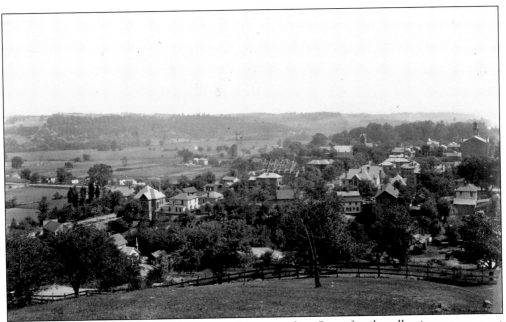

In this wonderful photograph from the small but revealing Snow family collection, one can get a bird's-eye view of a portion of Athens. The view is from the north and looks out over the town east of Court Street. Of note in the photograph are two things: on the right is the town hall, with its opera house addition still intact, and in the center of the picture the construction work on the new St. Paul's Church, which was completed in 1899, is visible.

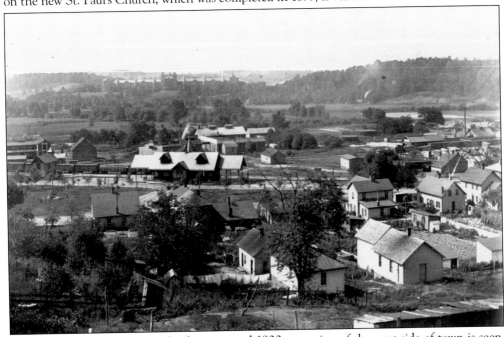

In this view of another part of Athens around 1900, a portion of the west side of town is seen. Taken from the top of Africa Alley (now Depot Street) or Smith Street, the Union Street depot, a collection of houses, and the lumber yard are evident. Looming in the distance on the hill is the imposing edifice of the Athens Asylum.

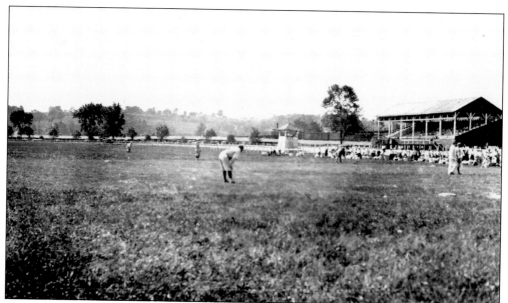

Since the mid-19th century, the Athens County Fair Grounds has provided residents of the town and county ample opportunities for recreation, such as this baseball game. Not only has the county fair itself been a yearly tradition for well over a century, the grounds have been used for many other varieties of fun. In this 1917 photograph, interesting details such as the train in the background and the long line of horse barns bring the scene to life.

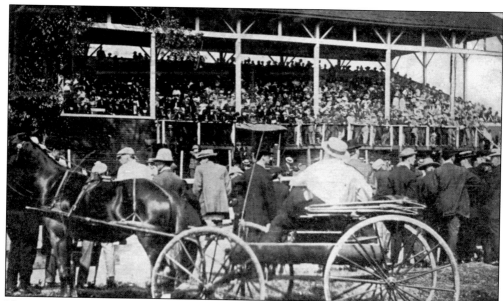

Harness racing at the Athens County Fair is one of the longest standing traditions in the community and it has provided annual fun and excitement to fans of horses and competition for more than a century. The fair itself always included various rides and sideshows on the midway, agricultural displays, livestock judging, food vendors of all types, and sometimes special events like the aeroplane flights that were a part of the 1913 fair.

Circuses large and small provided perennial entertainment to the residents of Athens through the 19th century and into the middle years of the 20th century. As is evident in this photograph from about 1895, the big top was a major part of the attraction. In the 19th and early 20th centuries, there were hundreds of small circuses that traversed the country, setting up for one or two shows, then loading up onto railroad cars and moving to the next town. By the 1960s, most had disappeared and had become another vestige of a vanished past.

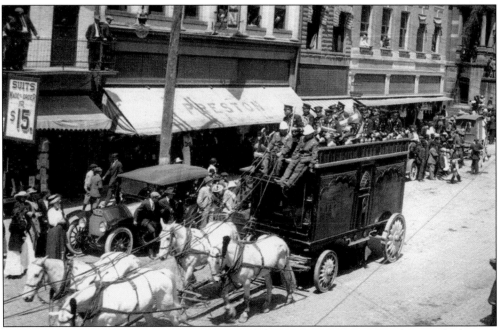

A much anticipated and almost required part of the circus experience was the parade through town. This photograph was taken of a circus wagon on Court Street in 1915.

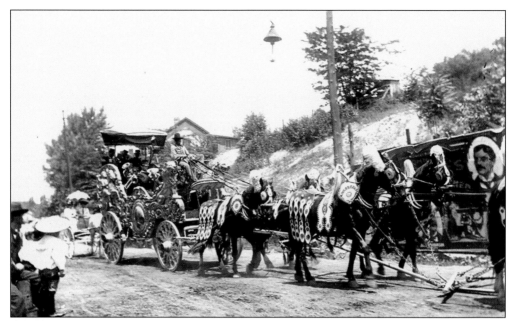

In this photograph from around 1890, a band wagon is pulled along a portion of West Union Street in Athens. The ornate wagon and the elaborately decorated horses were all designed to attract attention to the circus and its exotic offerings. The band would play as the wagon rolled along, attracting youngsters who would eagerly follow it to the circus grounds. Once there, they could perhaps secure a temporary job feeding the elephants in exchange for free tickets.

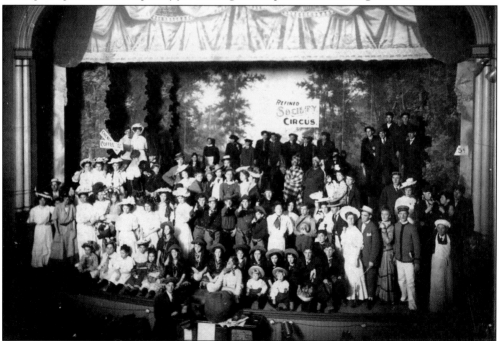

Community variety shows of all types, such as "the Refined Society Circus" shown here, made up an important part of the entertainment that was available to town residents in the era before film, radio, and television were pervasive.

Crystal Pool, which was built in 1927 and located on Factory Street behind the Athens Lumber Yard, provided years of recreation and fun to the children and adults of Athens until it was closed and replaced by a more modern facility on East State Street in the 1970s. Many older Athenians will have fond memories of hot summer afternoons spent at the pool.

On the midway at the Athens County Fair there were two types of food vendors, those who traveled with the show from fair to fair, and local organizations that used their food sales as a fund-raiser. The Kiwanis Club's shelter was one of the more popular eateries. This photograph was taken at the fair on August 6, 1958.

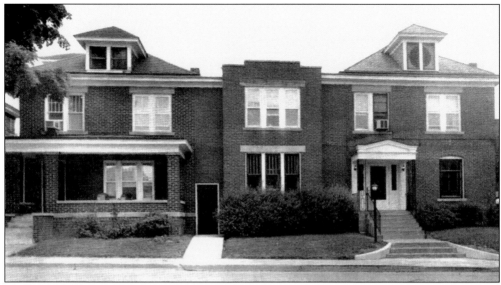

This is Sheltering Arms Hospital. It opened in 1921 as a birthing hospital but later developed into a full service medical facility. It was purchased by Dr. T. H. Morgan in 1947. By the 1960s, a move was on in Athens to build a more modern hospital, and in December 1967, construction on the new O'Bleness Memorial Hospital started. It opened on West Union Street in July 1970.

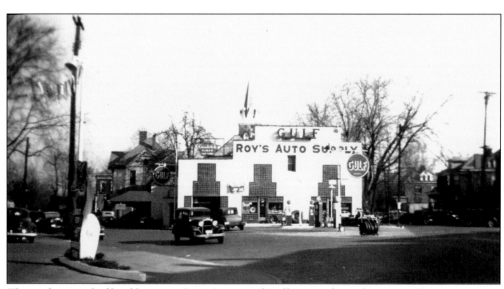

This is the parcel of land between State Street and Mill Street that is known as Flat Iron Square. For many years Roy's Gulf service was a good place to buy gas uptown. The building is actually what remained of the old Currier house pictured on page 42.

In these two photographs, one can see an all-too-familiar scene to longtime Athens residents—heavy snows in the winter. These two scenes are both along North Court Street at the corner of West State in November 1950.

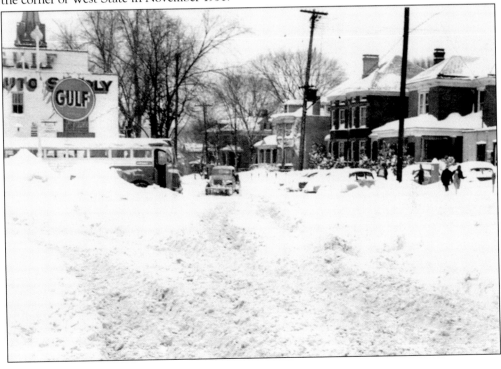

This photograph shows a group of Athens men who flew out of Athens on the first large airplane to take off from the Ohio University airport on October 11, 1959. The occasion was an excursion to Cleveland to see the Browns play the New York Giants. Among the men pictured here is someone special to this project. In the first row, standing with a hat on, third from the left, is James Anastas. Anastas is the person who collected many of the photographs in this book and he very generously donated his collection to the Athens County Historical Society and Museum for others to see and appreciate.

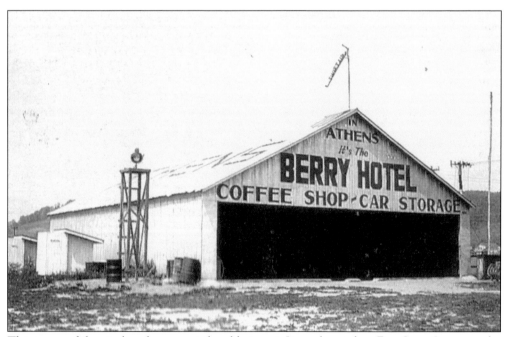

This is one of the airplane hangers at the old airport. It was located on East State Street on the edge of town. This is an area that was quite rural until the 1960s, when it began to experience some of the commercial development that is there today.

These three Athens girls are walking down Court Street during the Christmas season. Familiar signs of the times are present, including the sign for Steppes Beauty Shop. The date was December 14, 1947.

A group of Little League baseball players pause for the camera during a party to celebrate the end of the season. The date is September 8, 1958.

DISCOVER THOUSANDS OF LOCAL HISTORY BOOKS
FEATURING MILLIONS OF VINTAGE IMAGES

Arcadia Publishing, the leading local history publisher in the United States, is committed to making history accessible and meaningful through publishing books that celebrate and preserve the heritage of America's people and places.

Find more books like this at
www.arcadiapublishing.com

Search for your hometown history, your old stomping grounds, and even your favorite sports team.